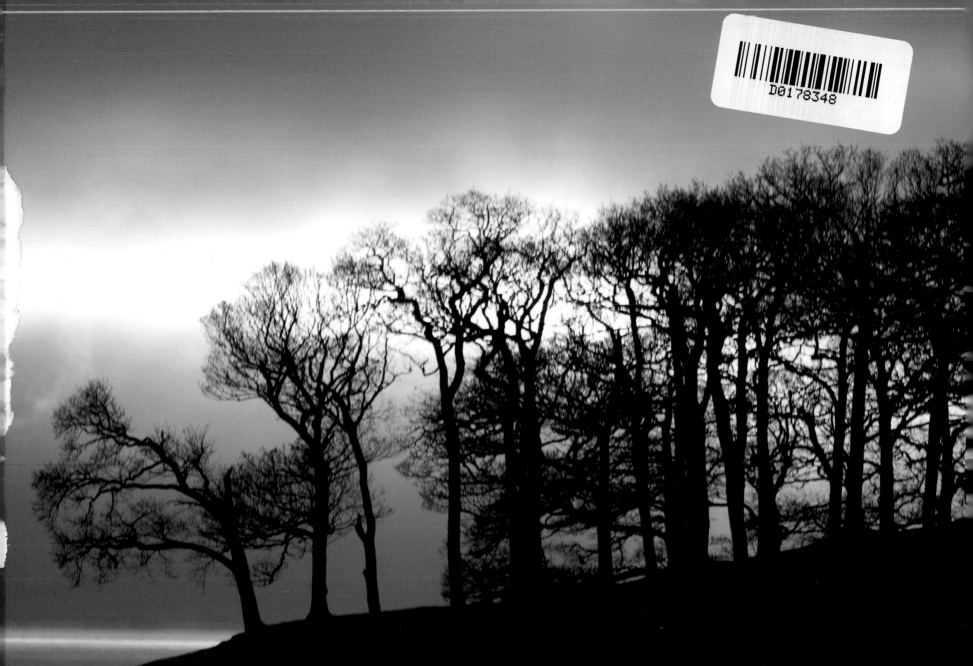

PHOTOGRAPHING TREES

EDWARD PARKER

Kew Publishing
Royal Botanic Gardens, Kew

CONTENTS

INTRODUCTION 5

Part One
HOW TO IMPROVE YOUR PHOTOGRAPHS 15

Composition 16
Foreground 22
Background 26
Light 29
Lens effects 35
Viewpoint 43
Organisation and planning ahead 46

Part Two
HOW TO TAKE CONTROL OF YOUR CAMERA 55

Taking control of exposure 56
Focus 61
Using aperture priority (A or AV) 66
Shutter 74
Flash 79
Image quality 82

Part Three
HOW TO PHOTOGRAPH TREES 89

Whole tree 90
Filling the frame 93
Tree trunks 96
Leaves 99
Bark 104
Fruits, seeds and flowers 108
Woods and forests 112
Scale 117

CONCLUSION 120

FOREWORD

My first experience of Edward (Eddie) Parker photographing forests was long ago now in 2001. We were in far northern Malaysia and had risen well before the first light. Eddie had gathered his gear and we headed deep inside the forest's darkness, moist, misty and alive with creature sounds. We chatted while Eddie set up, wondering at the beauty of the place and of other forests we had visited. We waited.

Slowly the first hint of light emerged and with it, the first haunting call of the Lars gibbons. Eddie moved into action and there was a ‹click› from the camera. There was no ‹click› ‹click› ‹click› as I – the uninitiated – had expected; he was holding open the aperture, soaking in the smallest rays of light brightening the forest before us.

'Too dark isn't it?' I inquired.

'No, it's perfect' Eddie said without taking his focus from his work. 'The very first of the very first light makes for the most magic of forest shots'.

So it proved. The resultant shots were wonders; some of them shown here in this magnificent edition. As Eddie held open that aperture, I felt that he was actually harvesting the forest's light; reflected from ancient trees, tiny ferns, climbing lianas, forest spirits – harvesting not destroying, sharing beauty not death.

Perhaps by photographing forests and trees we might inspire their protection. Confined now mostly to an office, I look at Eddie's tree and forest photographs whenever I need to reconnect. His photos take me back to that first morning, to other times spent in forests, and I am ready to strive again.

Beautiful photographs enhance our lives. This is seldom better illustrated than by the wonders of good tree and forest photographs; perhaps the hardest of all to take well. With this volume, thanks to Edward and to the Royal Botanic Gardens, Kew, we are all better equipped to get outdoors, to reconnect with the natural world around us, to harvest our own light, our own mysteries, from the trees and forests that surround us.

SCOTT POYNTON
Executive Director The Forest Trust, Geneva

A view at sunset as the mist begins to engulf the trees in the Eden Valley, Cumbria

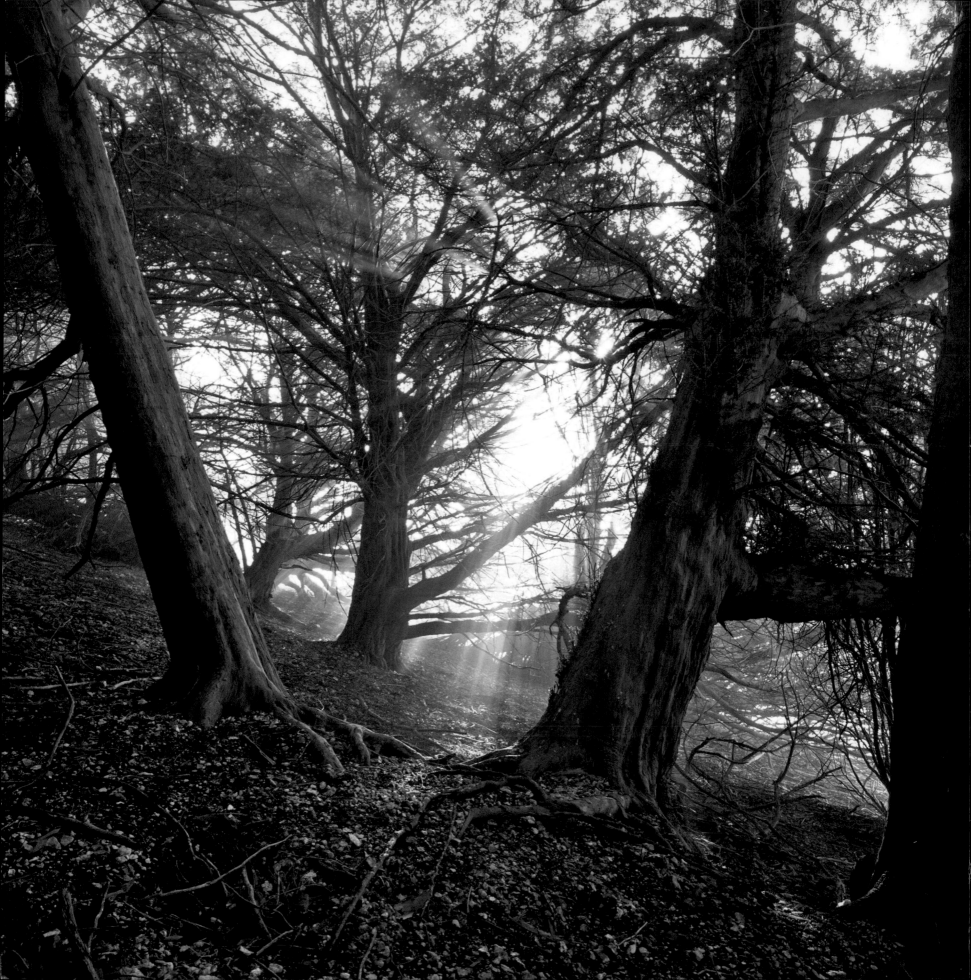

INTRODUCTION

A few years ago, a group of *National Geographic* photographers were asked, as an experiment, to put aside their expensive, high-tech equipment and go out photographing with fairly basic point-and-shoot, compact cameras. Needless to say, the results they came back with were stunning. This clearly demonstrates that there is so much more to photography than just owning expensive equipment; it's more a way of looking at the world.

The main idea behind this book is to explain that it is possible to take prize-winning and publishable photographs with fairly regular equipment, wherever you happen to be, if you know how. The book is very much designed to be helpful to photographers of all abilities and with all types of camera. The book is also designed to help you produce the very best images possible straight on to the memory card so that those of you who do not want to spend hours on the computer making adjustments in post processing can have an image that is pretty much ready to go as soon as it has been downloaded. For those of you who do enjoy the post processing of digital images, it will help you take images of the highest quality to work with. You will often hear photographers say that it is difficult to make a mediocre image good in post processing but that it is possible to make a good one great.

My hope is that this book will give you the tools to produce photographs that delight you and of which you can be proud. I think taking photographs

A rare pure yew forest on a misty, winter's morning, Dorset, England
Corfield medium-format camera, 21 mm (equivalent), 1 sec, F32

that are useful for your own purposes and that give you a real buzz personally are marks of success, while getting the images published and/or winning prizes in competitions is really just the icing on the cake.

One of the objectives of this book is to help you understand the limitations of your equipment and, rather than being restricted by them, work around them and actually use them to your advantage. It is also about how to get the very best images possible from the camera and lenses that you already own or have access to. This book is as much about the art of photography and seeing like a photographer as it is about mastering technique.

This is very much a personal book in which I will be using the benefit of my experiences over the best part of three decades to explain simple techniques that can help everyone improve their photography, even on a camera phone, before going on to explaining how to 'take control' of your camera through understanding more about the various settings that can be used. I like to keep things relatively simple so that I can work at speed and concentrate more on the creative process rather than fretting over technical issues. To this end I will be giving a variety of 'expert tips' throughout the book that may help you to find short cuts to better image taking.

My career as a photographer, writer and environmental campaigner has taken me to more than 40 countries, from Brazil to Vietnam and from the Congo to Greece, and my work has featured in countless books and magazines. I have written or co-written and photographed more than 30 books myself, including *Ancient Trees: trees that live for 1,000 years*, and I have had the privilege of working with a wide variety of organisations,

including the Royal Botanic Gardens, Kew, WWF-UK, WWF International, The Forest Trust in Switzerland, and many more. Most recently, I was the project manager for the Woodland Trust's Ancient Tree Hunt in the UK, running a Heritage Lottery Funded project to record 100,000 ancient, veteran and notable trees across the UK.

The book is divided into three main sections. The first part of the book is designed to help improve the impact of your photographs, but without you having to change the settings from those that you are already comfortable with. It is extraordinary how understanding a little about composition, the inclusion of foreground and background, what types of light are best for which type of photographs, can really help you improve your final photographs. I regularly run photographic courses with students of a wide variety of abilities and it gives me enormous pleasure to see spectacular photographs – in some cases absolute masterpieces – taken on the most basic of cameras set on 'auto' or 'program' mode. I am also delighted by just how incredibly ingenious people can be in everyday situations, and how some people are able to produce amazing images simply by viewing something commonplace in a new way. It is important to remember that many of the greatest all time photographs may have been taken on what today would be considered fairly basic and quite restrictive equipment.

In the second part I go on to explain how to take control of the settings on your camera in order to produce images of the highest quality that your equipment allows. In this part I will show you how to set up the camera to take the finest images and what needs to be taken into consideration before choosing how to set things such as ISO (sensitivity), RAW, JPEG etc. I will also explain the situations where it is best to use the camera in 'aperture priority' or 'shutter priority' modes, when to under and over-expose etc. By the end of the section you should have a good understanding of the different settings available to you on your camera and be able to identify when to use them.

Rainforest giant in Udzungwa National Park, Tanzania
Canon EOS 1v, 20mm, F2.8mm, 1/8th sec at F16 (tripod)

In part three I outline some of the many different ways to photograph trees and explain the decisions behind the final image. Effectively this will bring together the understanding of the techniques outlined in the first two sections and how they have been applied to a whole range of situations I have faced over the years.

The good thing about this book is that it doesn't require you to change or update your equipment in any way, but will hopefully inspire you – and show you how – to get the very best out of the camera and lenses you already have. Once you have mastered the techniques, then new equipment might be nice – but it's by no means essential.

As people who know me will tell you, I am very much a photo enthusiast. I love looking at all types of photographs and I like to see people of all abilities enjoying photography and taking photos they can be proud of. I hope this book inspires you to go out and take great photographs of all kinds of amazing trees.

A BRIEF INTRODUCTION TO DIGITAL PHOTOGRAPHY

Digital cameras operate in much the same way as film cameras used to but instead of a piece of film recording the image digital cameras have an electronic sensor. The sensor is a silicon chip covered in millions of photosensors each of which emits a small electrical charge when exposed to light. The minute variations in the electrical charge from each photosensor (which effectively contribute one pixel to the final digital image) are processed into a digital image before being 'written' or sent to a memory card.

DIGITAL CAMERAS

There are a mind-bogglingly large number of cameras on the market today which can make things quite confusing. However, the good thing is that digital cameras have advanced so much over the last 10 years that even

The fall in New England, USA
Canon EOS 7D 70–200 F2.8L, 1/125th sec at F4 (tripod)

relatively inexpensive cameras can produce excellent images that can easily be blown up to the size of a full page in a magazine.

Cameras today tend to fall into three broad categories; compact cameras, hybrid cameras and interchangeable-lens cameras. The price and specifications of each of these three types of cameras vary greatly too but for simplicity I will stick to these three broad categories.

COMPACT CAMERAS

Compact cameras are generally small, fairly straight forward to use and have a permanently fixed lens – usually a zoom lens of some sort. The reason that they can be small is that the image is registered on quite a small sensor, about the size of a little finger nail.

The quality of the results from these cameras has improved significantly over the last few years. Small, lightweight, easy to carry and largely automated, they are highly versatile and the perfect point-and-shoot option. Some have great sensors and fine optics, and most can produce very acceptable images that can be blown up to A4 size or beyond. Some of the best photographs taken on courses I have run have been produced on compact cameras. Their main drawback is that because of their small sensor, they need near optimal conditions for best results.

HYBRID CAMERAS

These are usually a little larger (and more expensive) than compacts and include many of the controls and features of DSLRs, such as full manual mode. They often come with remarkable zoom lenses, such as 28–400 mm (35 mm full-frame equivalent). In favourable conditions, hybrids can produce very fine images, but when set at high ISOs or using the lenses at their extremes, the quality can quickly deteriorate.

Lime avenue in Autumn

Canon EOS 1v 16–35mm F2.8L, (A 18mm) 1/8th sec at F16 (tripod)

INTERCHANGEABLE LENS CAMERA SYSTEMS

These are becoming increasingly available, in both compact camera systems (CCS) and digital single lens reflex (DSLR) cameras. The main difference between these two types of camera is the size of the sensor and the fact that DSLRs have a mirror which enables you to see directly through the lens via the viewfinder. The advantage of the CCS is that a smaller sensor allows for smaller and lighter cameras and lenses. There are some remarkable camera systems hitting the market that are small but still offer a range of high-quality lenses that are beginning to rival the best DSLRs. However, the price of these is often close to or even in excess of equivalent DSLRs.

DSLR camera bodies can cost from a few hundred to several thousands of pounds. The cheaper ones generally have the most common and popular APS-C sensors (see below), which can produce excellent images at a wide variety of sensitivity settings. The highest quality DSLRs have a full-frame (35 mm) sensor, able to record very high quality images capable of being blown up to billboard size.

SENSORS AND SENSOR SIZE

The world of digital photography has become quite technically complex and no more so than understanding sensor sizes and the number of mega-pixels available. There are a number of different sensor sizes available with modern cameras but the four main ones are:

1 Full-frame (35 x 24 mm) – used in the world's most advanced DSLRs
2 APS-C (28.7 x19.1 mm) – the most common size used in amateur and semi-professional DSLRs
3 Four-thirds (17.3 x 13 mm) – half the size of a full-frame sensor, but considerably larger and higher quality than most compact sensors
4 Compacts – relatively small (about the size of your little fingernail), producing reasonable quality images in very portable, often tiny, cameras.

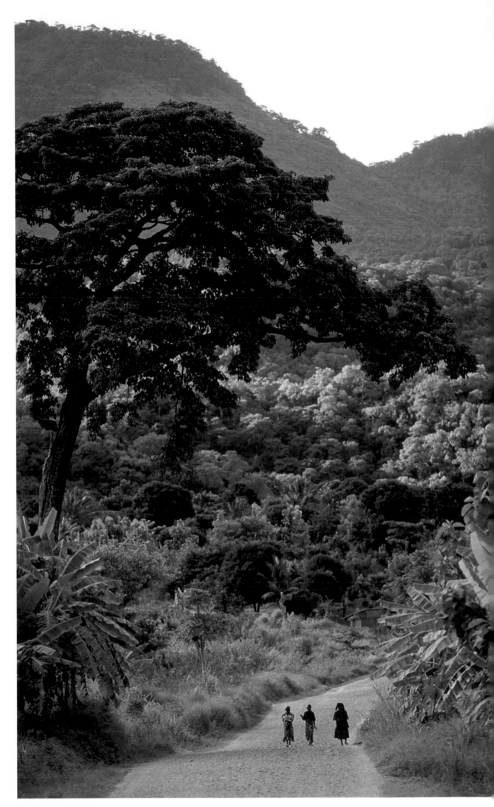

Udzungwa National Park, Tanzania
Canon EOS 1v, 135mm F2L, 1/250th sec at F2.8

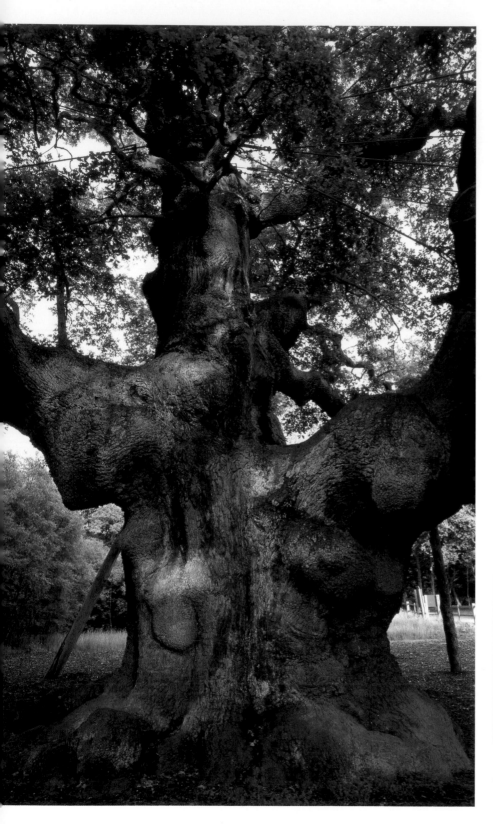

PIXELS

The number of pixels varies from camera to camera. This refers to the number of receptors on a sensor that can record information. The pixels are not a definitive way of assessing the potential quality of images produced by different cameras. This is because quality is a function of both pixels and the size of the sensor on to which they are crammed. Hence a 16 megapixel compact camera will not be able to offer the same quality as a 16 megapixel DSLR, which has a larger sensor over which the pixels are spread.

LENSES

There are a wide variety of lenses available for all makes of cameras. Compact cameras come generally with a zoom lens that covers from wide angle to short telephoto (often referred to as a standard zoom) which is not removable. Hybrid cameras often come with lenses that cover a large range of focal lengths such as 28-400mm (35mm sensor equivalent), which covers wide angle for landscapes, standard focal lengths for portraits and telephoto for wildlife and sport, but again are not changeable. The interchangeable lens cameras can have dozens of different lenses to choose from, from fish-eye super wide angle to lenses that are as powerful as telescopes.

For tree photography, unlike many other types of photography, it is possible to take superb images with a limited number of often-reasonably priced lenses. It is useful to have the ability to take what are known as wide angle, standard and telephoto photographs. This can be covered in several

> **Expert tip**
>
> If you haven't got a tripod and a cable release with you and you want to do a long exposure then there are other ways round it. I have been known to balance my camera on my rucksack or a towel and compose an image before setting the shutter release for a ten seconds delay. This enables me to plunge the shutter release and for the vibrations from my hand to die away before the actual image is taken.

The Major Oak in Sherwood Forest near Nottingham, England
Corfield 6 × 8 camera, 47mm lens (21mm equivalent), 1/15th sec at F11 (tripod)

lenses for interchangeable lens cameras or as a single zoom lens that covers all three which comes as standard on compact and hybrid cameras.

The good thing about tree photography is that great photographs can be taken using quite basic equipment. For sport and wildlife photography the larger the final aperture a lens can have the better, because the larger the aperture the more light can be let in. The more light that is let in, the faster the shutter speeds available to the photographer to help freeze the movement of a fast-moving sportsman or animal. These lenses can be very expensive – professional wildlife lenses can cost thousands of pounds – but trees on a calm day do not move around much so a fast shutter speed is not necessary.

Image stabilisation is also useful but not essential, again because of lack of movement in tree photography a tripod can be used.

Therefore the main decisions to be made by you regarding lenses for tree photography is first identifying what your needs are, then quality, weight and price.

DEMYSTIFYING SENSORS, LENSES AND FOCAL LENGTH

The advent of digital cameras with different sensor sizes has led to a bit of extra complication when it comes to the focal lengths of lenses and how the final image appears on the sensor. This is because the focal length is directly related to the final sensor size. In the past, most film cameras used 35 mm film and therefore the focal length of lenses was standard between camera systems. Today, only the professional systems have sensors that are

Dawn over the rainforest in Borneo
Canon EOS 1v, 300mm F2.8L, 1/125th sec at F5.6 (tripod)

what is termed 'full-frame 35 mm' sensors, such as the top-of-the-range Canon and Nikon cameras.

For example, when I use my 100 mm macro lens on my full-frame camera body, the effective focal length remains 100 mm. However, when I use my back-up camera, which has an APS-C sensor (as found on most entry-level and semi-professional DSLRs), the focal length effectively changes because the sensor is smaller. In this case, the conversion is 1.6 ×, which means the macro lens is effectively a 160 mm macro. This is great for adding extra focal length to telephoto lens, changing my 70–200 mm F2.8 lens, for example, effectively into a 112–320 mm F2.8 zoom. However, at the other end of the scale, my super wide-angle lens becomes equivalent to just a regular wide-angle to standard zoom lens, changing from 16–35mm to 25.6mm to 56mm zoom.

The wonderfully compact cameras that use the four-thirds sensor cover exactly half the area of a full-frame sensor. This makes the lens conversions very easy to make, with a straight doubling of focal length. For example, a 25mm lens is equivalent to a 50 mm full frame equivalent.

Confusingly, when the sensors become even smaller, lens focal lengths are given as '35 mm equivalents'. So a hybrid camera may be advertised as having a 28–300 mm lens or a compact camera with a 28–120mm zoom lens but here the conversion has already been made to a 35mm equivalent.

WHAT EQUIPMENT DO I USE?

As a professional photographer I have a kit bag designed to cover many eventualities so it is much fuller than yours needs to be for tree photography. My complete equipment list these days is:

Canon EOS 5D Mk2 (full-frame DSLR)
Canon EOS 7D (APS-C)

16–35 mm F2.8L
28–70 mm F2.8L
70–200 mm F2.8L
100 mm macro F2.8
50 mm F1.4
2 × converter
1.4 × converter
Flash
Tripod
Cable release
Cleaning cloth
10–20 Gig of memory cards
Battery charger and spare battery
Filters
Flash batteries

Using cameras with different-sized sensors effectively gives me a lens range of 16–640 mm. This is because the EOS 7D has an APS-C sensor which is smaller than the full frame EOS 5D Mk 2 and means that the focal lengths is 1.6 x longer which is great for telephoto work.

When I need to travel more lightly, for example in extreme conditions such as mountain walking, I can reduce this down to one camera body, three lenses (16–35 mm F2.8L, 50 mm F1.4, 70–200 mm F2.8L), a 1.4 × converter, cable release and lightweight tripod. I would also carry basic survival equipment, such as a torch, compass and exposure blanket, as well as a bit of food and water.

My most essential accessory has to be the tripod, which allows me to get shake-free images and to work in extremely low light, using exposures of tens of seconds or more if necessary.

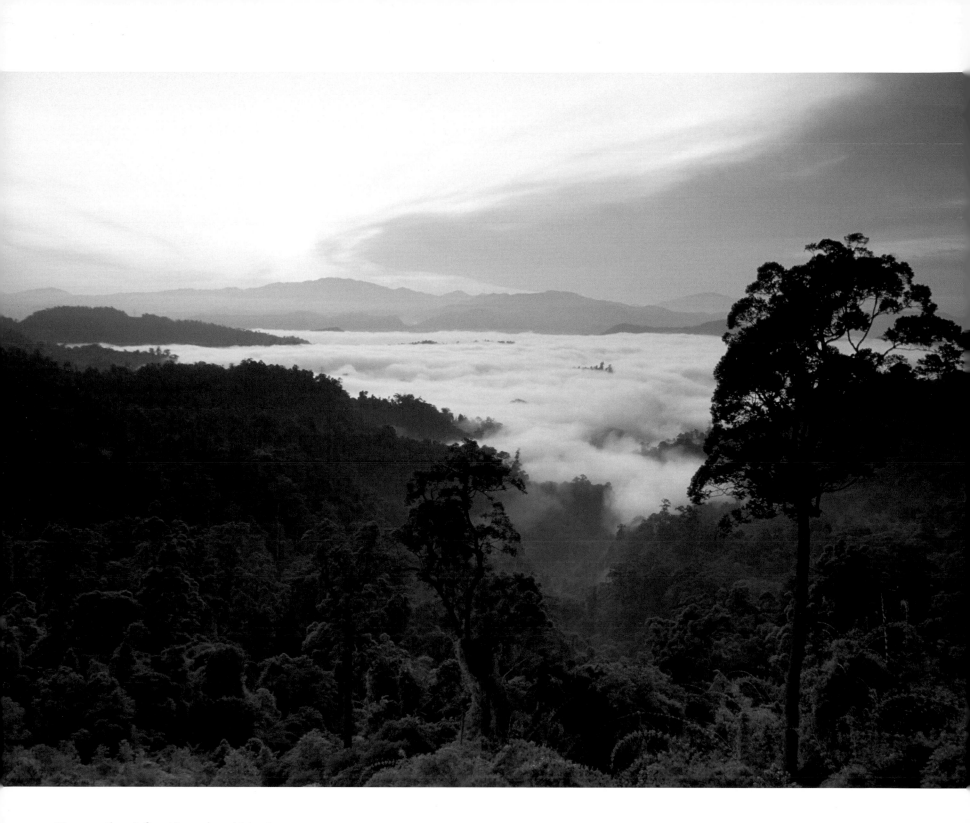

View over the rainforest in northern Malaysia
Canon EOS 1v, 28–70mm F2.8L, 1/15th sec at F11 (tripod)

HOW TO IMPROVE YOUR PHOTOGRAPHS

This section of the book is aimed at everyone, whatever their ability and irrespective of the equipment they are using. Most of what follows is just as applicable to film as well as digital cameras and even camera phones. It is a glorious opportunity to improve your photography without having to get bogged down in technical information or expend any money.

I believe that photography should be fun and creative and so this part allows you to leave your cameras on the settings that you are already comfortable with and explore ways of improving your photographs.

As people who attended my photo courses will tell you I am a photo-enthusiast in the broadest sense and I just love looking at good images and encouraging people to take images that they can really be proud of. I am not particularly precious about the technical side of photography and I sometimes feel that making students worry too much about technical issues can be counter-productive to creativity, especially when they are starting out. I am just as delighted to see great images taken on cameras which are set on 'auto' or 'program' modes as I am to see ones which are taken by photographers that are fully in control of all their settings.

With this in mind, what follows in this section are a number of techniques to help improve your photography without the need to change your equipment or even the settings that you are happy working with. It's more about how to spot a good photo opportunity and how to take advantage of the conditions at the time. It is also about leaning a little about how the human brain perceives flat images and what visual clues need to be included in order for the viewer to really enjoy the image.

I didn't train originally as a photographer and when I started out I had very little money to equip myself. However, I was determined to take photographs of similar quality to those seen in *National Geographic* magazine and so over time I learnt how to make the best of the limited equipment I had. This section is based on my experiences of more than 25 years and is the result of learning to 'problem solve' to get good images, and learning how to take advantage of whatever conditions are present.

COMPOSITION

Thinking about the composition of your photograph is one of the quickest and easiest ways of improving your results. This means looking at where the main components of the photograph are placed within the rectangle of the final image. Good composition is not only important in photography but in films and paintings too. It's why some photos, whether taken a hundred years ago or today, even simply on a mobile phone, can have such impact.

To understand why composition is important, it is useful to know how the human eye sees a flat image. Instead of viewing the whole photograph in one go, your eyes in fact rapidly scan the most important parts by dividing it into thirds. This takes a mere fraction of a second and is why you can often judge whether you like or dislike an image almost the instant you see it.

In effect, the eye scans the image by dividing it first horizontally into thirds and then the same again vertically. Anything that falls on these imaginary dividing lines immediately gets the attention of the brain, and even more so where they intersect. Equally, the parts of the photograph that don't fall close to these imaginary lines are often not noticed. This is useful to know when incorporating something in a scene that may be distracting, like a barbed-wire fence or a distant building.

The way the eye scans an image gives rise to what is known as the rule of thirds, or golden ratio, which has been used since Ancient Egyptian times. The people who painted the beautiful friezes that decorate the pyramids followed this 'third/two-thirds' rule – their depictions of people, for example, are two-thirds legs and one-third torso.

Once you know about the rule of thirds, you can see how it occurs in almost all artwork, including photography. Think of your favourite photos and you will almost always see that the horizon falls on one of the imaginary lines dividing the scenes into thirds. You will often hear photographers talking about whether to have 'one-third land and two-thirds sky or two-thirds land and one-third sky' for this reason. Other key features of a photograph are often positioned on one of these imaginary lines, and whatever falls on the intersection point becomes one of the image's strongest visual highlights.

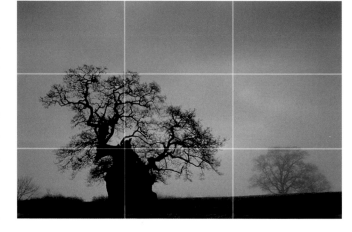

1,000-year-old oak in Dorset, England
Canon EOS 1n, 28–70mm F2.8L (set at 70mm), 15th sec at F5.6 (tripod)

Expert tip

Head for an art gallery or look at the work of famous photographers from the past – Ansel Adams, Henri Cartier-Bresson, etc. – to see how the rule of thirds has been employed in some of the world's greatest photographs and paintings.

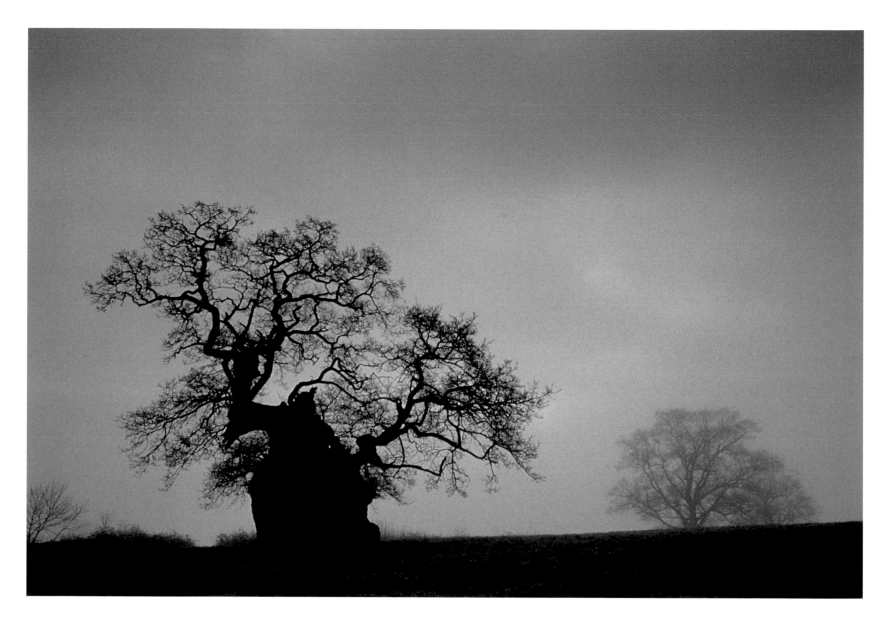

I really enjoy watching the opening or key scenes in a blockbuster movie and looking out for how the cameraman and director have employed the rule of thirds. Even on the news you will often see the correspondent in front of a news story set off to one side of the frame, so they are positioned on one of the imaginary third lines.

Look at the image of the ancient oak tree silhouetted against the pink dawn sky and then at the smaller version superimposed with a grid. See how the composition follows what is comfortable for the eye to scan. The horizon is one-third of the height of the photo and the sky makes up the other two-thirds. Not only that, but the oak tree is offset to fall on one of the vertical third lines. If the tree had been in the middle, the eye would have scanned around it at first and the whole image would have been much less effective.

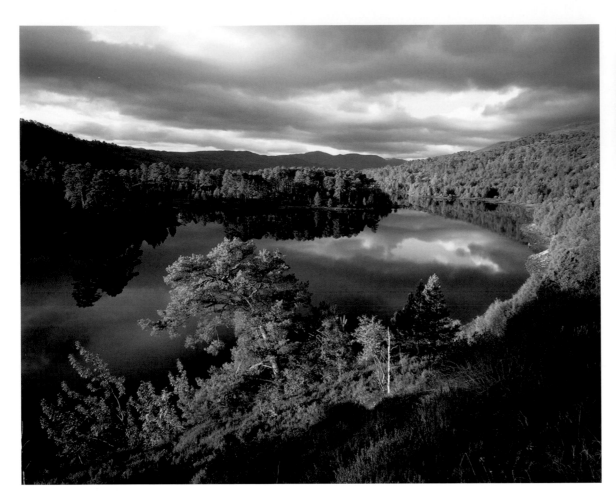

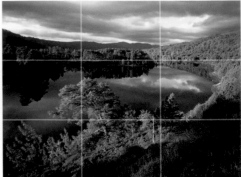

Caledonian forest around Loch Affric, Scotland
*Corfield media format camera, 1/15th sec, F16
(on tripod)*

The photo of the ancient oak is one of my favourites, not because it was particularly difficult to take, but because of what it represents. I was commissioned, along with 70 other photographers, to take a photograph at dawn on 1 January 2000 – the dawn of the new millennium. Other photographers were stationed at locations such as Ayres Rock in Australia, tropical islands in the Pacific or at the foot of a glacier in South America, whereas I was in a soggy field in Dorset with a thumping hangover and had to make the best of the overcast and misty conditions. Fortunately, I had a wonderful subject and the photograph looked great in the book, its impact largely due to the strength of the composition.

When you look at the photograph above of Scots pines and birch trees around Loch Affric, do your eyes scan it in a particular order? In theory, you should look first at the trees on the water's edge at the bottom left of the image, which sit on one of the imaginary third/third dividing lines. You should then follow the curve of the loch edge up to the right, before sweeping round along the far loch edge/horizon back across to the left. You can use the same technique to get the eye of the viewer to travel down a woodland path or finally fall on a small figure among the trees. It is fascinating to discover that by using composition it is possible to steer the viewer to see parts of a photograph in order. It is especially powerful where there is a jarring juxtaposition between elements of the image. It is even possible to make parts of a scene less noticeable, such as a pylon or building, by positioning them away from the imaginary third/third dividing lines and therefore areas where the eye scans.

You might think that this technique might not apply to photographing individual trees, or even parts of trees, but it does. Have a look at the beech

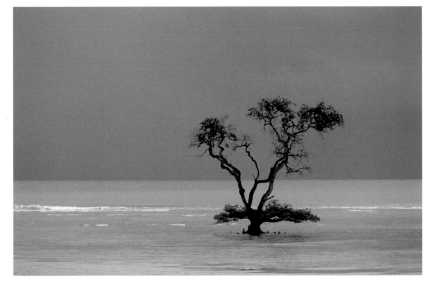

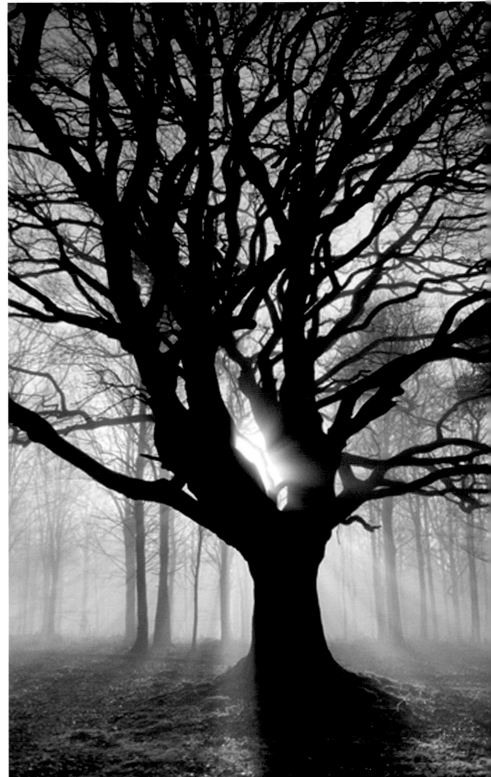

tree taken on a misty morning and you will see that the trunk occupies the bottom third and the branches the top two-thirds. Generally, the rule of thirds applies whether you are photographing a vast forest or individual trees, and right down to close-up details of leaves.

But remember, the rule of thirds is exactly that – a rule, so there are exceptions and times when it doesn't apply so much. I tend to take a series of differently composed images of the same subject because sometimes having the main subject in the centre of the image can work really well. I have found, for example, that with mirror-like reflections of trees beside water the composition feels more comfortable with the horizon in the middle of the image.

Overleaf is a photograph taken in the flooded forest of the upper Amazon, where the water level changes by around 15 m between dry and wet season.

The 50/50 composition works perfectly with these trees, which in a few weeks will be completely under water, with pink dolphins chasing fish through their branches.

The example below is taken in a very exotic location which is not available to everyone. However, it is possible to take the same sort of image in a local park or at a local river. I often head for the parks in London which have fabulous trees along the edges of the artificial ponds and lakes. I find the reflections particularly stunning with the brilliant colours of autumn reflected in the water.

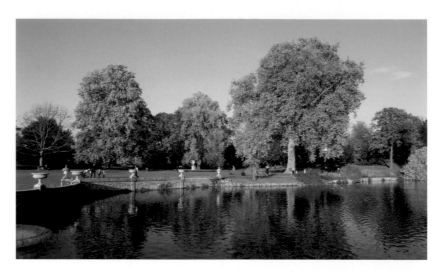

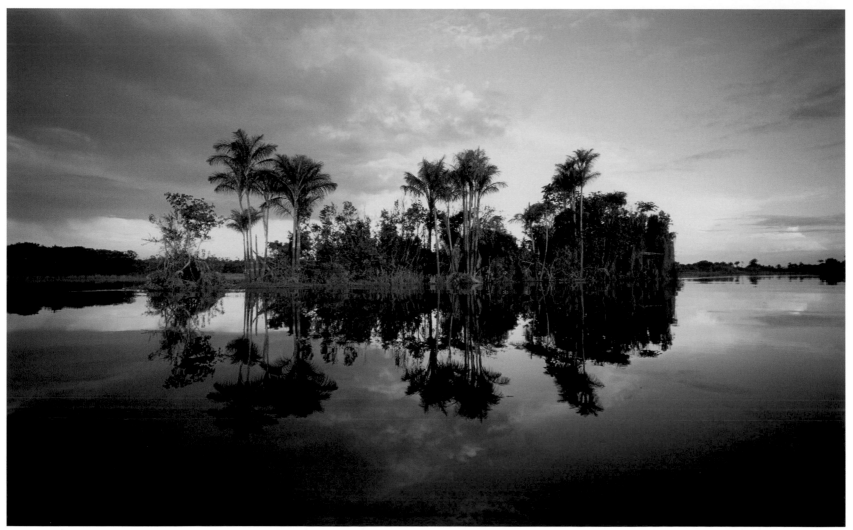

Finally, there is composition that takes into account how the final image may be used in a publication. I have learnt through experience that even producing a great image doesn't guarantee it will be selected for use in a publication because there may not be an appropriate space in which to place words or a title or that the main subject falls on the crease across a double page. The designers look for images that will fit particular types of layout – a vertical image for a cover or full page, a horizontal image with plenty of space around the subject where they can place text, an image that they can crop square, and so on.

Look at the image of a rainbow over a tropical rainforest in a remote part of Eastern Borneo. This image has been selected for publication numerous times because of its versatility. It can be used as a cover, with the title at the top and sub-titles in the sea at the bottom. It can be used full page. It can be cropped square or tall and thin. This flexibility means it has been published more often than if I had not given some thought to the possible final uses of the image. It's always preferable, if you have time, to take a variety of compositions – vertical and horizontal.

Hopefully you will now have an understanding of how good composition can really make an image. However, make sure you don't get overly anxious or preoccupied with this aspect, as you might lose some of your invention or art. Do what I do – take the first image that occurs to you (just to make sure you have one), then see if you can improve on it by using different compositions and thinking about the rule of thirds.

Trees in autumn colour, Kew Gardens, London, England
Canon EOS 5D, 16-35mm F2.8L, 1/60th sec F8

The 'varzea' or flooded forest on the upper Amazon in Brazil
Canon EOS 1v, 20 mm F2.8, 1/60th sec, F8

Rainbow's end in Eastern Borneo. A view of the mangroves with tropical rainforest rising behind on the coast of East Kalimantan (Borneo) Indonesia.
Canon EOS 1v, 300 F2.8L, 1/250th sec, F2.8

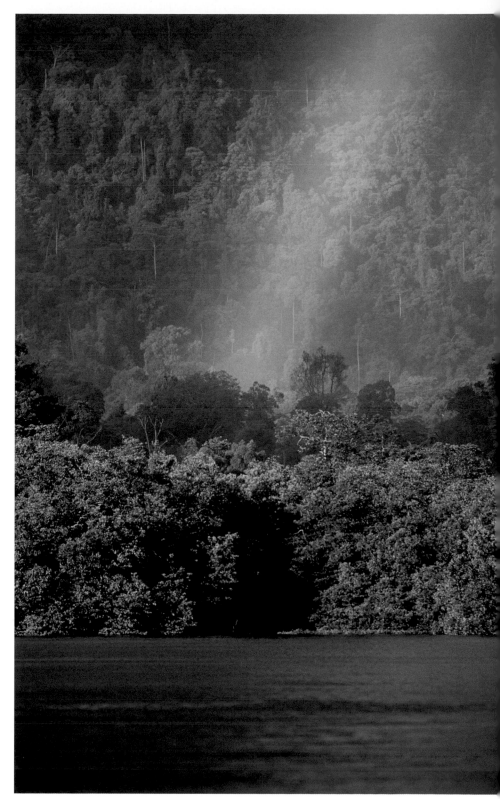

FOREGROUND

The human brain is a complex and wonderful thing. It works at phenomenal speed to interpret the world around us by calculating distances – how close or far away things are to us. It also works out the distances relative to each part of a scene. What is interesting is that when a person is confronted with a two-dimensional image, such as a photograph or painting, the brain seeks the same visual clues to work out the perspective and scale as if it were a scene in real life.

The inclusion of foreground is one of the easiest and quickest ways to improve your photographs. It is particularly useful for landscapes, such as forest scenes, but it applies to pretty much all types of photography. Foreground helps the viewer's brain to understand the perspective of an image and it can also be used to lead the eye into a scene. Curiously, the foreground doesn't always have to be dramatic or even in focus for its inclusion to greatly enhance an image.

Renaissance painters realised this as early as the sixteenth century and made sure their paintings had a foreground, mid-ground and background, so the eye of the viewer could understand the perspective. The more visual clues you include, and the better the composition, then the better the photograph will appear to the viewer. The brain is so fast that judges in major photographic competitions, who have to sift through thousands of images, say it is often possible to spot a great photograph with the briefest of glimpses.

One of my favourite photographic subjects is a Scots pine that lies almost horizontal to the ground on the shore of a lake near where I live (opposite). When the water level is low, the roots are exposed – see how I have used them as a powerful foreground, leading the eye into the image.

I used a similar technique in the image right, not only to show perspective but also to highlight a curious feature of mangrove trees – the hundreds of 'breathing roots' poking out of the mud.

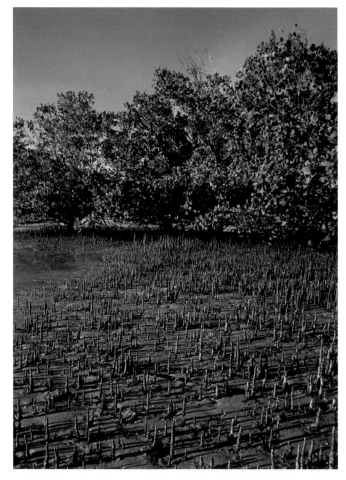

Mangrove trees with 'breathing' roots, Mafia Island, Tanzanian coast
Canon EOS 1n, 20 mm F2.8L, 1/30th sec at F16

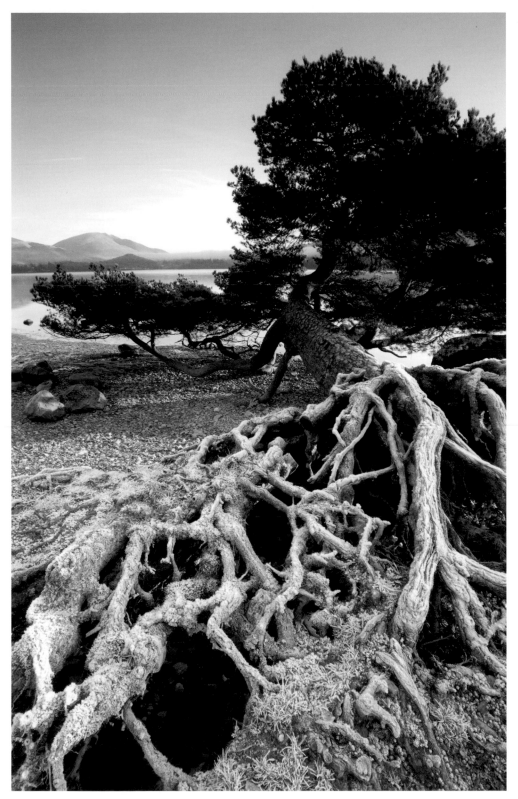

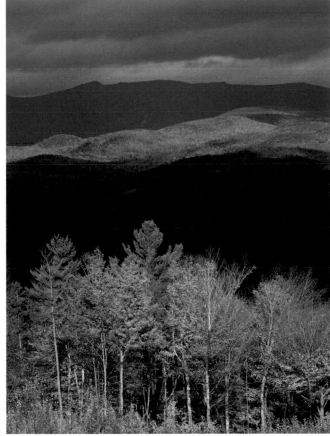

In the photograph above I have used the brightly lit trees as a strong foreground to help show the scale of the autumn colour across the New England landscape. For this image I waited for nearly half an hour because I could see that sooner or later the sun would light the brilliant autumn foliage in the foreground which has been made even more dramatic by the area of dark behind.
Canon EOS 7D, 70–200 mm F2.8L, 125th sec, F8 (on tripod)

Exposed roots of a Scots pine, Lake District, England
Canon EOS 1Ds, 16–35 mm F2.8L, ¼ sec, F22 (on tripod)

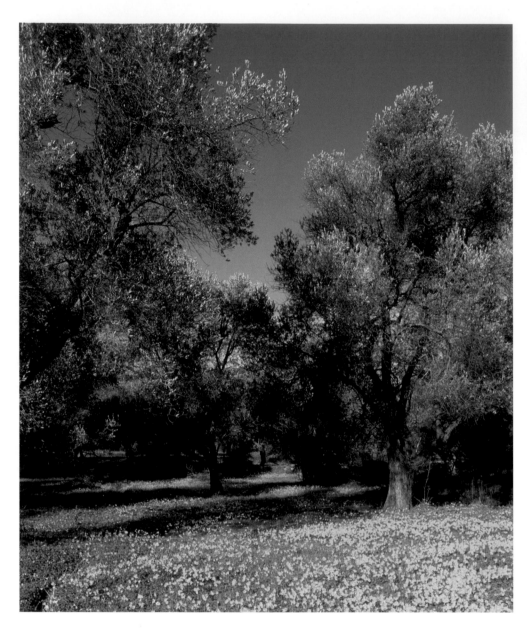

A snowy scene in Cumbria in the north of England
Canon EOS 1Ds, 28–70 mm F2.8L, 1/60th sec, F11

Olive grove on the Greek island of Crete
Canon EOS 1Ds, 28–70 mm F2.8L, 1/60th sec, F11

Expert tip

When you're photographing a tree on its own or in a forest in spring, try using flowers such as bluebells as foreground – take the image low to the ground with a wide-angle lens.

In early January, the ancient olive groves of Crete are carpeted with brilliant yellow flowers, providing the perfect opportunity to create a stunning foreground (above).

The wintry scene, above right, is greatly enhanced by the inclusion of the snow-covered branch as the foreground. It is a very helpful technique to include foreground in a scene like this especially when there is a large expanse of rather uninteresting sky. Interestingly, when there is mist or in this case where falling snow softens and slightly blurs the outlines of distant objects then the inclusion of close foreground in a image allows the brain to understand why the distant objects are slightly indistinct and adjusts its understanding to make the image work. A photograph on a misty day without foreground just gives the impression that it is a poor unsharp photograph.

Foreground is important, even in great sweeping scenes such as the early morning rainforest photograph opposite. The ridge of trees poking through the mist helps to make sense of the vast scale of the scene.

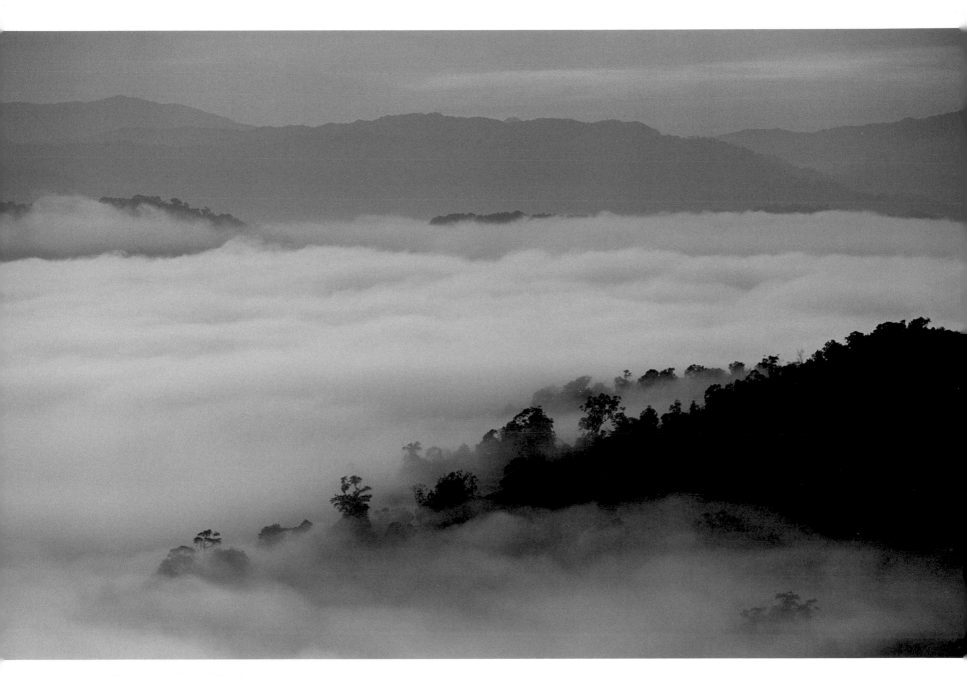

Tropical rainforest in northern Malaysia
Canon EOS 1v, 300 mm F2.8L, 1/30th sec, F5.6 (on tripod)

BACKGROUND

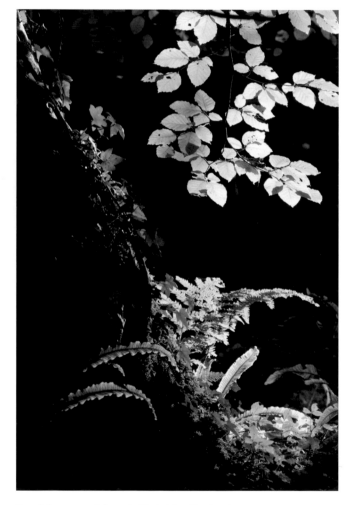

Beech leaves and ferns in Yorkshire, England
Canon EOS 5D, 135 mm F2L, 1/250th, sec F4

It is important to consider how the background will contribute to a photo. Backgrounds can be completely out of focus – just a series of blobs of colours and shapes – or part recognisable, or completely in focus as in a great sweeping landscape.

Sometimes I want the background to be neutral, so the subject stands out. This can be particularly effective with leaves or groups of leaves. I often select a single leaf and line up the shot so the background is in deep shade. This allows the brightly coloured leaf to stand out against a non-distracting black, which can look really effective. The same is true of animals and birds. This technique can also be used on entire trees in stormy weather, where a brilliantly lit subject stands out against a brooding black or dark grey sky. Do bear in mind though that if there is a lot of black in the image and the subject is brightly lit, then the camera may struggle to arrive at the correct exposure. In these conditions, it is usually best to underexpose by one or two stops (see Part Two – Taking control of exposure).

It is often difficult to take a successful photograph in a forest when the sun is bright and high in the sky. However, there are often ways to turn conditions to your favour when at first they may seem less than ideal. In the photo on the left, for example, I was attracted to the backlit leaves and ferns and moved around until I had positioned myself in such a way that a patch of deep shade provided a non-distracting background. This helped to ensure the gorgeous greens really stood out.

I like to look for interesting backgrounds, such as a fabulous sunset or a series of out-of-focus shapes and blobs of colour, to make an image more arresting. For trees and forests, the main background opportunity is going to be a beautiful sky or vegetation (either in or out of focus). However, in urban environments a tree set against an interesting building can look spectacular. Close-ups of fruits, seeds and blossoms can all be enhanced with a well-chosen background. The same is true of forest and woodland wildlife.

In the photograph below I loved the background before I found a subject. My hope was

to focus on the olives and leaves and create a slightly mystical feeling with the outfocus shapes of the trees in dappled Mediterranean light. In many ways it is not a conventional image of trees but I like the atmosphere it creates. On the same trip I used a similar technique this time using the Acropolis as the background because the photograph was intended to illustrate a section of a book on the mythology of olive trees.

The silhouetted palm trees, overleaf, provide the foreground to a fabulous background of a sunset over the China Sea from Nha Trang in Vietnam. It is often a good idea when using sunsets as a background to wait until well after the sun has dipped behind the horizon because often the most fabulous colours occur briefly a few minutes after sunset.

The background to the scene of monkey puzzle trees high in the Chilean Andes, overleaf, is what I jokingly refer to as an Old Testament sky. The portentous black clouds and rays of light in the background really make the photograph.

Sometimes a simple background can greatly enhance an image and also help to locate it. Autumn in New England, in north-eastern USA, is a spectacular annual event, with hundreds of square kilometres of colourful trees. However, with this image, overleaf, I chose a simple clapperboard house as the background. This not only helps the brilliant orange leaves stand out, but also locates the tree as very much in New England.

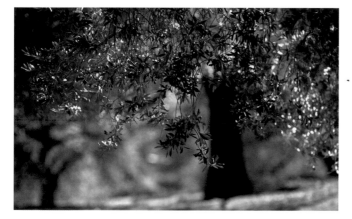

Olive grove on Crete
Canon EOS 1v, 135 mm F2 L, 1/500th sec, F2

Dragonfly in the rainforest of Costa Rica
Canon EOS 7D, 70–200 mm F2.8L, plus 2 × converter 1/500th sec, F2.8

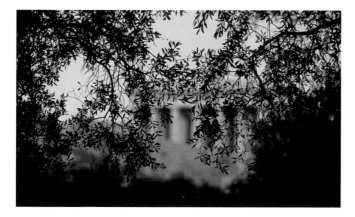

Olive trees at Acropolis in Athens, Greece
Canon EOS 1v, 135 mm F2 L, 1/30th sec, F8 (on tripod)

Expert tip

Make a mental note if you see any isolated trees standing on ridges or hills. Then, if there's a fabulous sky or sunset you can go back and photograph them against a stunning backdrop.

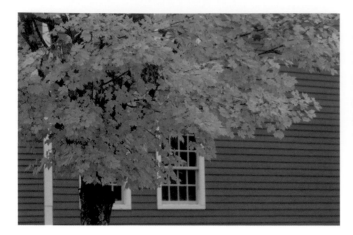

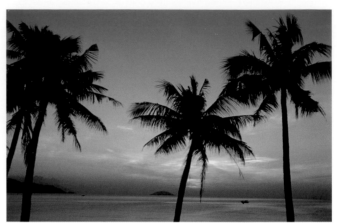

A maple in full autumn colours, New England, USA
Canon EOS 7D, 135mm F2L, 125th sec, F4

Palm trees on a tropical beach in Vietnam
Canon EOS 1v, 28–70 mm F2.8 L, 1/125th sec, F8

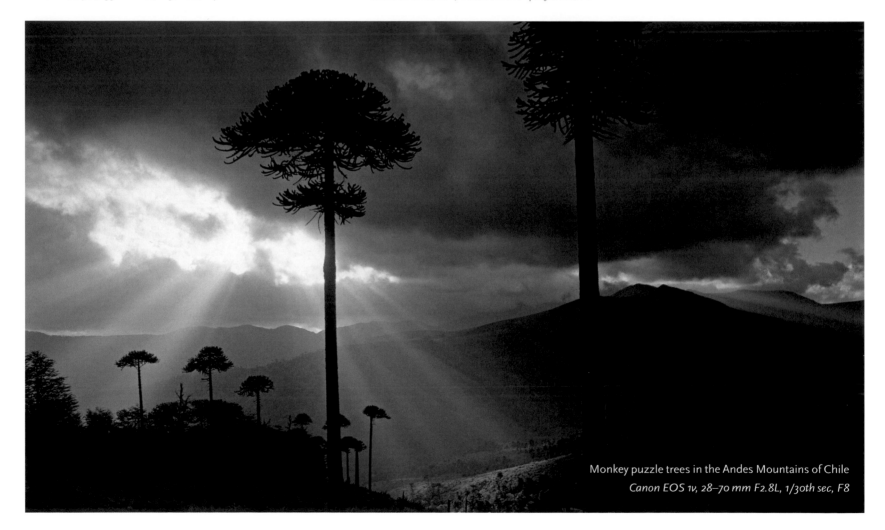

Monkey puzzle trees in the Andes Mountains of Chile
Canon EOS 1v, 28–70 mm F2.8L, 1/30th sec, F8

LIGHT

Whatever the conditions, you can always turn things to your advantage to get better photographs. For example, I often head out on drizzly, overcast days, when other photographers are heading home, especially if I want to photograph deep in a forest or woodland. Many of my photographs from the rainforests of Borneo and the Amazon were taken in damp, cloudy conditions (or sometimes in torrential downpours), because the light spreads evenly under the canopy and the greens can appear richer, especially when leaves are wet. At the end of a day photographing in the rainforest, or in temperate woods, I usually leave soggy, yet happy.

Have you ever noticed how a scene can appear quite ordinary when the sun is directly overhead, yet look fabulous when the sun is low on the horizon? This can be due to the warm tones of the afternoon or morning light, but it is also because when the sun shines on an object from a low angle it creates a highlight on one side of it and a shadow on the other. This makes it easy for the viewer's brain to understand the three-dimensional nature of the object. Imagine two photographs of a tree trunk. The first is taken like the worst of party snaps, with a flashgun on top of the camera, which produces a flat, dimensionless, unflattering result, looking almost like a cut-out against a black background. The second photograph is taken when the sun is low and shining from the side. This gives the tree trunk a highlight on one side and a shadow on the other, immediately helping the brain to understand that it is tubular in shape.

On my photo courses, I have been teased because I am often heard to say, 'These are the perfect conditions for tree photography', irrespective of the weather outside. In fact, the greatest enemy to the tree/flower photographer is wind. Without wind, it is possible to use a tripod and take photographs in all conditions, even moonlight. I have learnt to exploit even the most unpromising conditions, because as a professional photographer I need to be able to produce results good enough for a full page in a Sunday supplement regardless of the weather. I once went on a ten-day trip to the Andean cloud forest, where it rained heavily

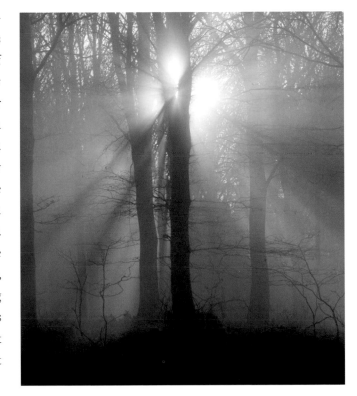

Rays of golden light stabbing through the mist in a beech wood, Dorset, England. Backlighting on a misty day can lead to some dramatic lighting effects. By hiding the sun behind one of the trees I have not only avoided possible flare but I am able to use an exposure which helps makes the rays standout better against the forest background.
Canon EOS 1Ds, 135 mm F2L, 1/60th sec, F8 (on tripod)

every day, yet I produced some of my best images, one of which was highly commended in the Wildlife Photographer of the Year competition.

Below I consider the various qualities and angles of natural light that can be used to enhance your photographs.

HARD AND SOFT LIGHT

The easiest way to understand the difference of effects between hard and soft light is to go outside in different conditions, hold out your hand and see what type of shadow it casts. Hard light occurs on cloudless days (or when using a flash) with little or no haze. In these conditions the shadow of your hand will be bold and have a clear, sharp outline. When the sun is diffused through mist or thin clouds, the shadow of your hand will be less distinct and less black and, with softer, less distinct edges.

Soft light creates a scene where there are still shadows to provide the visual clues for the brain, but the difference between highlights and shadows is less extreme. This is useful for the photographer because a camera sensor can only record a certain range of bright and shady areas before parts of the image become too light (burned out) or the shadow areas become too dark and become areas of black without any recorded detail. Soft lighting is the sort of lighting that portrait photographers often use to create flattering images of people. Hard light, on the other hand, especially when shining across a subject, highlights the texture of an object. It can help show every crease and wrinkle, which is great for trunks and bark.

ANGLE OF LIGHT

This refers to how high in the sky the sun is, and also its angle relative to the camera's axis. And it can make or break a photograph. Probably the most difficult time to photograph a tree or forest is on a cloudless summer day when the sun is high in the sky. This creates dark shadows at the base of the tree that can hide the trunk. However, the same tree photographed in late afternoon (when the light is coming from a lower angle and from one side) will not only illuminate the subject more evenly, but also give better visual clues as to its shape. Have a look at the two examples right. One shows a mulberry and a tulip tree, taken in high summer with the sun overhead. The other is a yew tree (which are notoriously difficult to photograph because of

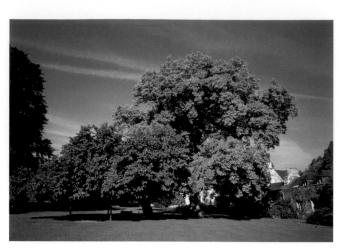

Tulip tree and mulberry trees John Evelyn's garden, Sussex, England
Canon EOS 1v, 29–70 mm F2.8, 1/125th sec, F11

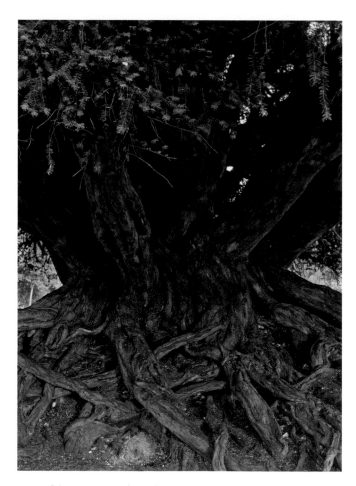

Beautiful serpentine roots of an ancient yew tree, Surrey, England
Canon EOS 1n, 28–70 mm F2.8L, 1/15th sec, F13 (on tripod)

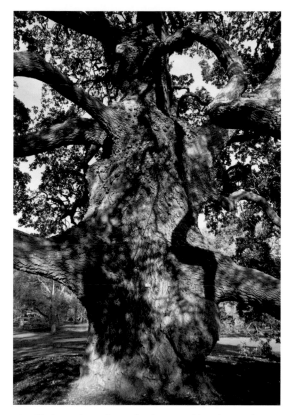

Hard light making deep shadows and bright patches
Canon EOS 5D, 16–35mm F2.8L, 1/45 sec, F11

Montezuma cypress
Canon EOS 5D, 135 mm F2L, 1/60th sec, F8 (on tripod)

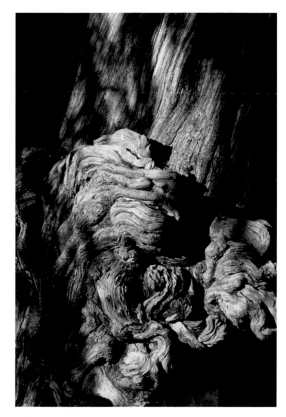

'El Tule' trunk burr
Canon EOS 1n, 135 mm F2L, 1/250th sec, F5.6

their dark green foliage) – a shot I waited several weeks to take, until the low summer sun, diffused through light cloud, created the perfect lighting.

The photograph of a tulip and mulberry trees, taken on a bright summer's day, is also slightly disappointing because of the angle and quality of the light where the deep black shadows under the canopy hide the detail on the trunks.

The photograph above left shows how hard, high angled light can affect an image. I find the deep shadows and bright patches uncomfortable to look at.

to water, its preferred location. In my opinion, this photograph is almost perfectly lit – the low sun is diffused by some early morning clouds, providing light that is soft yet shows the texture and shape of the trunk perfectly.

The photograph above right shows the same species of tree, but this time it is of part of the trunk of 'El Tule', another swamp cypress, one of the world's largest trees, growing in Oaxaca, Mexico. The photograph is taken with the same lens and almost the same settings, but the angled light this time is hard, helping to show the texture of the burr and bark.

LOW ANGLE AND SIDE LIGHT

I particularly like it when light from a low sun falls across a subject. Not only does it make for highlights and shadow areas, which provide visual clues to help the brain understand a scene, but it also brings out the textures.

Above centre is a photograph of a Montezuma cypress tree growing next

BACKLIGHT

In almost every season, backlighting provides fantastic opportunities to the tree photographer. In spring, when the leaves are thin and translucent in temperate forests, shooting into the light can give beautiful results. In winter, the leafless trees can provide the perfect silhouette for a sunset or dramatic

sky. Similarly, feathery palms on a tropical beach can form distinctive silhouettes against a tropical sky. Backlighting is also superb for close-ups of leaves.

Backlighting is great for silhouettes of winter trees such as the conifers standing on a promontory in the Lake District in England, on the right.

OVERCAST CONDITIONS

Far from being a hindrance, overcast skies are the friend of the tree and forest photographer. On many occasions they have enabled me to get a photograph

> **Expert tip**
>
> Backlighting is great for leaf photography, especially when they are more translucent in spring and autumn. See the ginkgo leaf above.

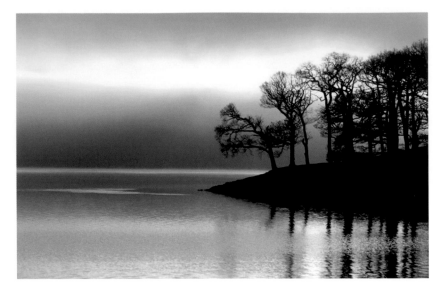

Conifers in the Lake District, England
Canon EOS 1Ds, 135 mm F2L, 1/120th sec at F2.5

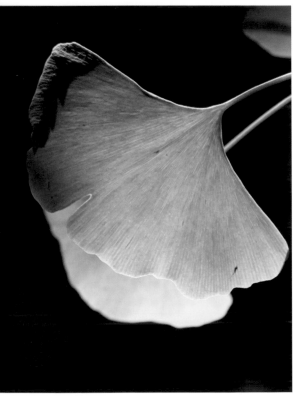

A back-lit ginkgo leaf
Canon EOS 5D, 100 mm macro F2.8, 1/250th sec, F4

Ancient oak trees at Dalkeith in Scotland
Canon EOS 1v, 16–35 mm F2.8L (at 24 mm), 1/30th sec, F11

that would have been virtually impossible if the sun had been shining brightly. I'm known for getting really excited if it turns cloudy when I'm working in the rainforest or deep in a temperate wood, or even with an ancient tree that has a challenging background such as a power station.

The advantage of overcast conditions is that the light spreads evenly throughout the forest or wood, especially under a dense canopy. This allows you to photograph scenes that otherwise are difficult for the sensor on your camera to register properly. This is because if the range of highlight and shadow in a photograph is too great the patches of brilliant sunlight can just

become white, registering very little detail, while the deep shadow can often become just areas of black, again with little detail recorded.

Below is a photograph of a spectacled bear in the cloud forest of the Colombian Andes. It was raining hard, but despite what might have been considered to be challenging conditions the photograph ended up being Highly Commended in the Wildlife Photographer of the Year competition.

Another benefit of working under overcast skies, is that you can take photos of trees from almost any angle. On an overcast day the light falls on all sides of a tree compared to sunny days when one side may be brightly lit

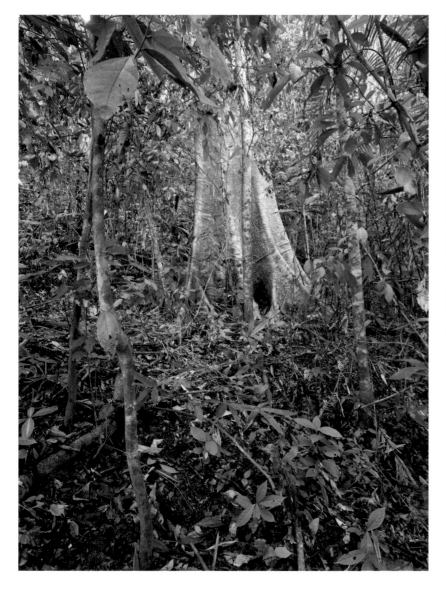

A spectacled bear eating a bromeliad in the cloud forest, La Planada, Colombia
Canon EOS 1v, 28–70 mm, 1/30th sec, F2.8

The interior of the rainforest, East Kalimantan (Borneo) Indonesia
Canon EOS 5D, 16–35 mm F2.8L, 1/4 sec, F16

Expert tip

Before photographing into the sun, always check that the lens and filter are clean. Also, try hiding the brilliant ball of the sun behind a branch or trunk to reduce flare (those unwanted streaks of light that can ruin a photograph).

Autumn woodland
Canon EOS 5D, 135 mm F2L, 1/5th sec, F11 (on tripod)

and another in deep shadow. This is particularly useful when a subject has an unfortunate background from one viewpoint, for example in some urban situations, or if the sun never quite falls on the best side.

The previous page shows a rare rainforest tree in Borneo taken in overcast light. See how every part of the photograph is so evenly lit that it is all plainly visible.

When I arrived to photograph the autumn colours in the USA last year (above), I wasn't disappointed to see the wet, cloudy conditions. Here, the overcast sky and drizzle helped to saturate the gorgeous autumn hues.

LENS EFFECTS

The Crowhurst yew in Sussex, England
Canon EOS 1v, 16–35 mm (at 21 mm), ½ sec, F22 (on tripod)

The use of the right lens can really increase the impact of a photograph. This may sound a bit advanced but actually this section is merely to make you aware of the possibilities of either using different lenses or using the zoom lens that is on you compact or hybrid camera. This involves selecting the right lens (or zoom setting) for the situation, as well as the right lens (zoom setting) to create an effect. Again, it has much to do with the way a viewer's brain perceives images. For example, the perspective of a human eye is equivalent to a particular focal length of a camera lens. With a full-frame 35 mm DSLR, this is around 100 mm, with an APS-C camera, it's around 70 mm, and with a four-thirds camera, around 50 mm. With a compact camera that has a three-or four-times zoom, it is towards the upper end of the zoom.

This may sound a bit technical, but if you imagine most compact zooms have a wide-angle, standard and telephoto setting on the zoom lens, it is easier to grasp. Wide angle is the setting where it is possible to get a large amount of a scene in the photo, telephoto is the setting where you zoom in on distant object, and standard is somewhere in between the two.

Almost every camera now has the possibility to zoom or for the lenses to be changed. The word zoom refers to the ability to vary the focal length of a lens, although some people confuse it with telephoto, which means to have an effect like a telescope.

When talking about lenses and focal lengths, I find it best to divide them into five broad categories. The middle three – wide-angle, standard and telephoto – are all pretty much standard for DSLR and compact cameras these days. There are also some compacts with super zooms that effectively have a super-telephoto setting. Generally, however, the super wide-angle and super telephoto lenses tend to be the preserve of professionals or advanced amateurs.

Sacred rainforest tree in Laos
*Canon EOS 1v, 16–35 mm F2.8L
(at 18mm), ¼ sec, F16*

Fallen sweet chestnut seeds,
Berkshire, England
*Canon EOS 5D, 16–35 mm F2.8L
(at 16 mm), 1/30th sec, F16*

SUPER WIDE-ANGLE

These lenses create fantastic distortion of perspective. The wider the angle, the larger the foreground appears and the further away the background appears in the image. My camera equipment includes a wide-angle zoom that covers from super wide-angle to wide-angle settings in a 16–35 mm F2.8L lens. The effect can be dramatic. Look at the sweet chestnut tree above. Set at super wide (16 mm), the foreground appears to be huge and the background distant. Obviously, a single chestnut seed is not as big as the tree, but this is how it appears using a super wide-angle lens.

Photographing trees on a super wide-angle setting can give a tapering effect if the camera is tilted up or down. This is where the trunk appears to narrow much more quickly than in real life. The effect is quite noticeable on the 3,000-year-old yew tree on p.35. I quite like the effect, but many people (especially architectural photographers) don't. Special shift lenses can be used to correct the distortion.

To take the photograph above of an ancient and sacred tree in the rainforest of Laos, I used a super wide-angle, simply to get the whole tree in. Often, in a forest situation, it is impossible to walk far enough back to capture a whole tree. The super wide-angle lens gives it a towering quality.

WIDE-ANGLE

This setting is available on practically all cameras, including compacts. It is incredibly useful for what I term 'environmental' photos. By that I mean objects, in this case trees, shown in their environment or surroundings. Wide-angle settings allow for great landscapes, forest interiors and people in forest situations, without the dramatic and sometimes off-putting distortion of perspective that is a feature of super wide-angle lenses. The image below left is a perfect illustration of the merits of wide-angle photography.

The teak and coconut plantation is beautifully located in its valley environment, below rainforest-covered hills.

In the image below right, I used the 35 mm setting to get a reasonably wide-angle shot without throwing the background too far back, so that the gorgeous shaft of light was still prominent enough. It was the first photograph on a trip to the Malaysian rainforest. It took just a couple of minutes for me to get out of the vehicle and take the shot, by which time I had a large leech hanging from my neck.

Expert tip

You can minimise the distortion, especially the tapering effect, when using wide-angle and super wide-angle lenses by keeping the camera body as perpendicular (upright) to the ground as possible.

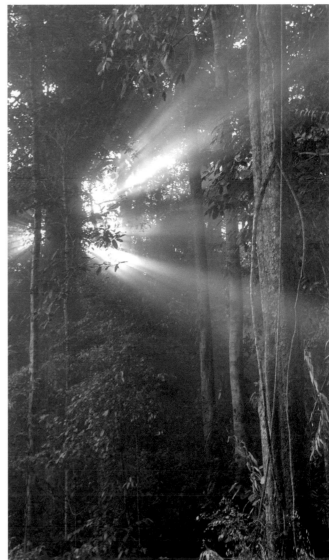

Sun rays in the mist of the
rainforest, northern Malaysia
*Canon EOS 1v, 28–70 mm F2.8L
(at 35mm), 1/30th sec, F8*

Teak and coconut plantation, Sulawesi, Indonesia
Canon EOS 1v, 28–70 mm F2.8L (at 28mm), 1/60th sec, F10

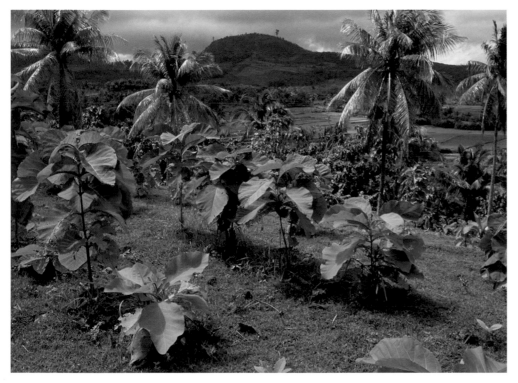

Monkey puzzle trees in the snow
high in the Andes Mountains, Chile
Canon EOS 1N, 28–70 mm F2.8L
(at 50 mm), 1/90th sec, F4.5

Teak plantation, Java
Canon EOS 5D, 28–70mm F2.8L (at 50mm), 1/60th sec, F5.6

Liquidambar tree at Kew Gardens, England
Canon EOS 5D, 28–70 mm F2.8L (at 70 mm),
1/125th sec, F5.6

STANDARD

This generally covers the middle section of the zoom range of a compact camera lens. With my full-frame DSLR, it is within the 50–100 mm range (35–70 mm on APS-C cameras). Using a standard lens or lens setting creates little or no distortion of perspective compared with how the human eye interprets a scene. You might think it's not an important setting, because it doesn't create any dramatic effects of perspective. However, it is a really important and useful setting, especially for scientific documentation, because it gives the most realistic representation of trees. If a photograph is taken looking up a tree with a super wide-angle or even a wide-angle lens, then it can appear dramatically and unrealistically tapered. For a documentary photograph it would be better, if possible, to walk back and re-take the shot using a standard lens setting.

Above right is a tree in fabulous autumn colours at the Royal Botanic Gardens, Kew. See how natural the image looks using a lens setting of 70 mm.

I find the 50–75 mm range perfect for both trunk details and whole trees, like the snow-covered monkey puzzle, above left.

The fabulous red trunks of redwood trees in Sequoia National Park, California, USA
Canon EOS 1n, 135 F2L, 1/250th, F4.0

A podocarp tree emerging from the rainforest, Central Kalimantan, (Borneo), Indonesia
Canon EOS 1n, 300 mm F2.8L, 1/500th sec, F2.8

TELEPHOTO

Telephoto lenses and zoom settings (100–300 mm on a full-frame DSLR or 70–200 mm on an APS-C camera) have the effect of compressing perspective by making the background appear much closer to the mid-ground and foreground than the human eye would perceive it. The telephoto setting is perfect for isolating a distant tree and for highlighting interesting backgrounds.

Above is a photograph of a group of Californian redwood trees. Note that the trees on the right, despite being several meters closer to the camera,

appear to be virtually level with the trees on the left. I used a 135 mm lens to create this effect.

Telephoto lenses are great for isolating distant trees. This photo of a giant podocarp tree is taken from a logging road with a 300 mm lens to make it fill the frame. Telephoto lenses are also great for isolating trees in busy urban parks, where by standing well back and just focusing on a single tree it is possible to wait until there are no distracting people in the frame. This can help them look as if they are almost in wild or rural settings.

This row of ancient sweet chestnut trees at Croft Castle, Herefordshire, England, have the appearance
of being really close together, but in fact are quite well spaced
Canon EOS 40D, 135 mm F2L (equivalent to 210 mm on the smaller sensor), 1/30th sec, F11

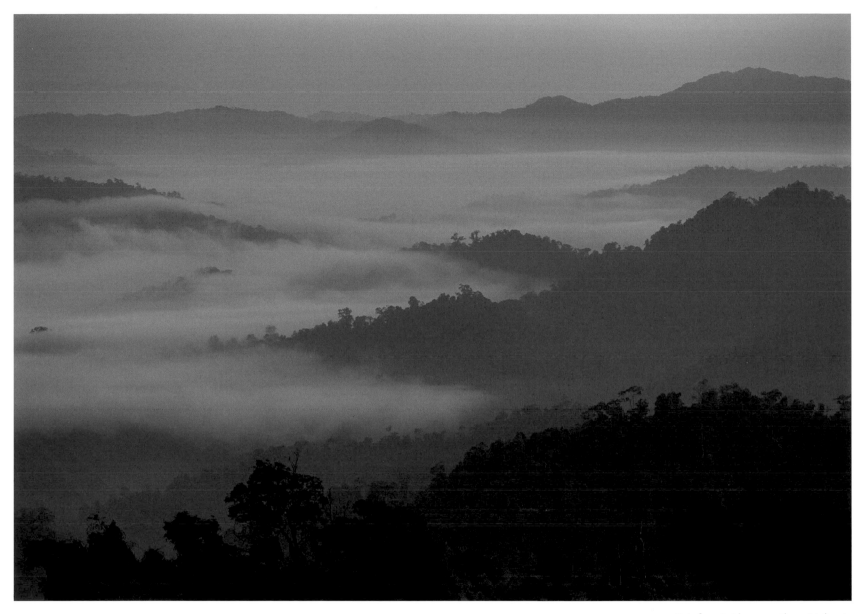

Rainforest ridges, northern Malaysia
Canon EOS 1v, 300 mm F2.8L with 1.4 converter (equivalent to 420 mm F4L lens), 1/30th sec, F5.6 (on tripod)

SUPER TELEPHOTO

Super telephotos lenses are generally the preserve of wildlife and sports photographers. These professional lenses are generally heavy and very expensive. Their effect is to be able to isolate distant objects and also really compress perspective, so the background appears much, much closer than in real life.

See how, in the photograph above, the forested ridges appear almost two dimensional, as if they're stacked on top of each other, when they are actually a kilometre or more apart.

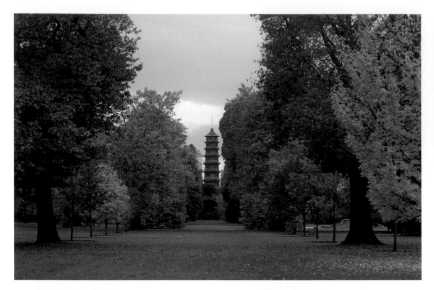

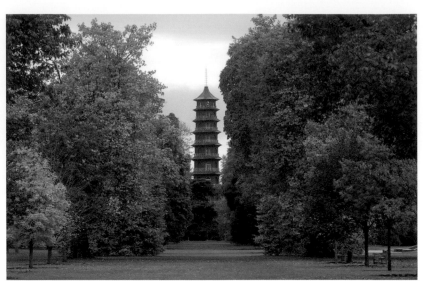

1 *EOS 7D, 16-35 F2.8L, (set at equivalent of 28mm) 1/60th sec, F8*

2 *EOS 7D, 70-200 F2.8L , (set at the equivalent of 150mm) 1/250th, F5.6*

Three views of the Pagoda at
Kew Gardens in London, England

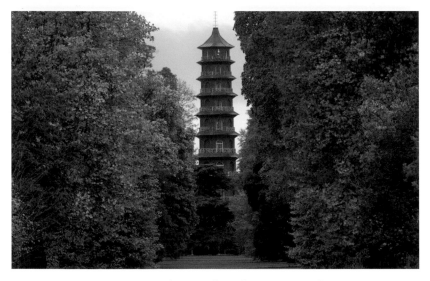

3 *EOS 7D, 70-200 F2.8L, (set at the equivalent of 320mm) 1/500th , F4*

Expert tip

If the tree you are photographing has an unfortunate background, try using a wide-angle lens or setting and moving closer to your subject. This can mean the background can be obscured by the tree or looks much further away and so less intrusive.

THE EFFECT OF DIFFERENT LENS SETTINGS

Above are three images taken at the Royal Botanic Gardens, Kew, showing the effect of using lenses of differing focal lengths on the same scene. I have used the Pagoda in the background as a reference point to demonstrate what happens to perspective.

The first photograph is taken with a 35 mm lens. Note how distant the background is. The second is taken at around 150 mm and gives the appearance that the lines of autumnal trees are closer together and also closer to the Pagoda. In the final image, which is taken at the equivalent of 320 mm, the Pagoda has become almost the main subject. The whole scene looks much flatter, because of the amount of compression caused by this focal length of lens.

VIEWPOINT

Ancient oak, near Inverness, Scotland
Canon EOS 1v, 29–70 mm F2.8L (at 50 mm), 1/125th sec, F8

It's well worth spending time seeking out an interesting viewpoint before you take your shot. I can often be seen pacing around a tree or in a forest checking whether there are any particularly good angles to take a photograph from. For example, some trees have an oval-shaped cross-section to their trunk, which means that from one angle it may look much wider than from another. I have even been known to cross over to a hill opposite to get a better view and use a telephoto lens to help isolate the tree.

Sometime the most obvious viewpoint – from head height, straight at the tree – proves to be the best, such as with the Scottish oak that seems to have pretensions of being a baobab one day (left).

Another straightforward but nonetheless effective starting point is to stand at the base of a tree and look upwards. I like this view, especially when using a wide-angle lens. In the photo of a lace-bark pine on p. 44, I moved in close and angled the camera upwards, mainly because the bark is the tree's key feature, but also because the stunning blue sky complements the grey trunk perfectly.

I took another photograph on p. 44, of more than a billion monarch butterflies all leaving on the same day on 23 March, in a small pine forest about 150 miles north of Mexico City. This phenomenon occurs every year as the butterflies begin their migration north, some as far as Canada. I looked straight up between the trees into the deep blue sky to help ensure that the butterflies stand out. Those in the centre and on the right are backlit by the sun, and I have used one of the trees to mask the sun itself, so I don't have any exposure or flare problems.

The photograph on p. 45 is of buriti palms scattered across the cerrado in central Brazil. It's taken from a small aircraft to get the high-angle view. Note how the closest trees act as the foreground, and the low-angled morning light slanting across the scene helps the viewer's

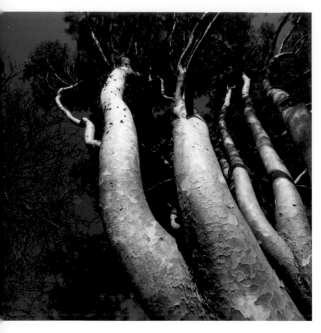

Lace-bark pine at Kew Gardens , England
Canon EOS 5D, 16–35 mm F2.8L (at 18 mm),
1/40th sec, F16

View directly down from a canopy walk way
in the rainforest, Costa Rica
Canon EOS 5D, 16–35mm F2.8L, 1/30th sec, f8

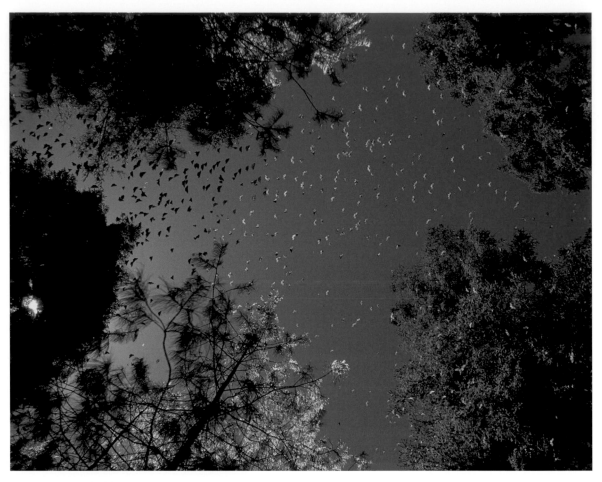

Over a billion monarch butterflies migrating on the same day
Canon EOS 1v, 16–35 mm F2.8L (at 20 mm), 1/200th sec, F5.6

Me on a forest walkway, East Kalimantan (Borneo) Indonesia
Canon EOS 1v, 16–35mm F2.8L, 1/8th sec, F11 (tripod plus 10 sec delay)

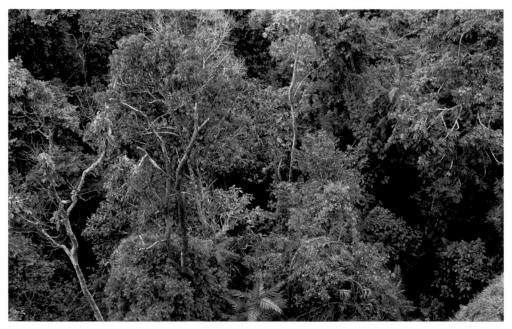

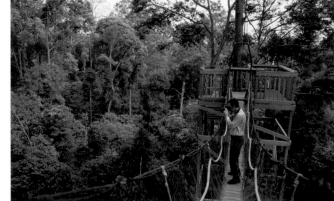

brain to understand it in terms of depth and the three-dimensional shape of the trees. You do not have to be in an airplane or in a remote location to take advantage of this type of viewpoint. I have often asked permission to go into office blocks to get a good angle on trees in an urban park. Also there are often locations with steep hills or even cliffs where this view point is possible too.

On the opposite page you can see me on a canopy walkway, looking for a good angle on the forest and keeping an eye out for birds and mammals, such as hornbills and flying squirrels. Beside that is an image looking down into a rainforest in Costa Rica.

After more than a week of heavy rain when I was travelling through the Andean cloud forest, the sky cleared briefly and I was able to see the vast expanse of forest in which I had been photographing the local people and spectacled bears. With the help of a local guide, I found the perfect vantage point, below. I used the closest tree ferns and trees as the foreground and composed the image according to the rule of thirds. The background of rugged mountains was a bonus and helped to establish the location of this magnificent forest.

Occasionally, I have the opportunity to go high into the treetops to photograph the forest below and the surrounding tree canopy. Again, you do not have to be anywhere too exotic to be able to take advantage of this sort of view point. At the Royal Botanic Gardens, Kew, in London and other botanic gardens there is sometimes a canopy walkway that visitors can ascend. I often get similar views from road bridges over forests too.

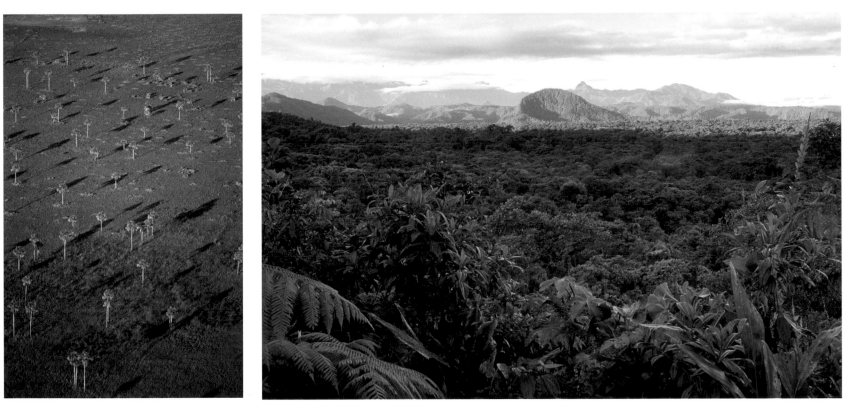

Buriti palms in the morning sun photographed from a small airplane, Mato Grosso, Brazil
Canon EOS 1v, 135 mm F2L, 1/500th sec, F2

A view of Andean cloud forest, near Pasto Colombia
Canon EOS 1v, 28–70 mm F2.8L (at 28 mm), 1/30th sec, F11

Expert tip

Working in the rainforest can prove a bit problematic when looking for a good viewpoint. I find that taking tree photographs from a bridge or boat allows for more variety than in the forest itself.

ORGANISATION AND PLANNING AHEAD

One of the key areas of photography which is often overlooked and which can help improve the results of your photography with little or no change in equipment or even settings, is organisation. It is interesting that people often think I have been lucky when I have been able to take a striking photograph, and sometimes I have. However, I spend a lot of time trying to engineer my luck by research and planning.

I find most of my tree photography is done under tight time restrictions and on a limited budget, which makes efficient planning a top priority. When working on the book *Ancient Trees – trees that live for 1,000 years*, for example, I often had only a couple of days in each location to get the necessary photographs – three days in Lebanon, three days in South Korea, two days in the White Mountains of California for the bristlecone pine, and so on. As a result I have become good at planning and problem solving.

When I'm considering working on a project with trees, I immediately divide the trees I am thinking of photographing into evergreens and non-evergreens. With deciduous trees, there are particular times of year when they are at their most photogenic, whereas, in theory, conifers can be photographed all year round. So in my planning and calculations, I start with the trees that offer the most limited photographic opportunities. I may need to capture their autumn colours or their springtime blossom, for example, or it may simply be that access to the location is tricky at certain times of year.

The bristlecone pines in California, for example, are generally found high in the mountains, with the very oldest trees at the highest and coldest elevations. These trees are inaccessible to most people for more than half the year, because of deep snow and icy conditions. This means that trips to see them have to work around times when the trees are at least accessible.

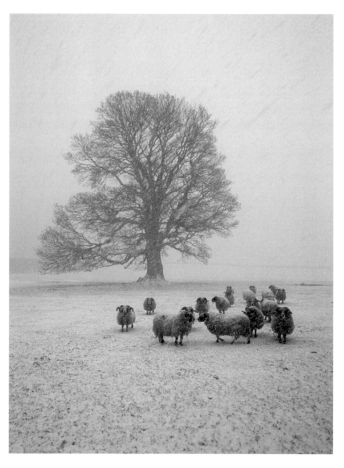

Rams and sycamore tree in heavy snow in Scotland
Canon EOS 1v, 16–35 mm F2.8L, 1/30th sec F5.6

One would think that taking trees in the tropics would mean that it would be possible to photograph pretty much at any time of the year, especially as the trees are generally in leaf all year round. However, I still have to consider the seasons mainly for the practical reason of just being able to move about. In South-East Asia, the monsoon rains can make roads impassable, cause landslides and get photographers very soggy. Also, there are times when the trees flower or fruit which can add interest.

Baobabs are often called the upside-down tree. This is because they are in leaf for only a small part of the year and for the rest of the time their bare branches look like roots. This photograph of the world's largest baobab,– with an astonishing girth of over 17 m required considerable planning.

Firstly, I planned to be in South Africa at a time when air tickets were cheaper and also when the baobab trees were in leaf. Then I had to find out where the largest tree might be and how long and difficult it might be to drive and find it. The tree was close to the Zimbabwe border but the village wasn't marked on the maps that I had. However, I knew the nearest small town and it was there I started asking. Eventually, I was able to find this giant tree but not until I had had a lot of fun in my hire car on deeply rutted tracks and getting stuck in deep sand. In the end I had around an hour with the tree before having to head back to civilisation and before the light drained from the sky because I didn't fancy spending a night in the car in a place full of elephants and lions.

The world's largest baobab *Canon EOS 1n, 28–70 mm F2.8L, 1/60th sec, F8*

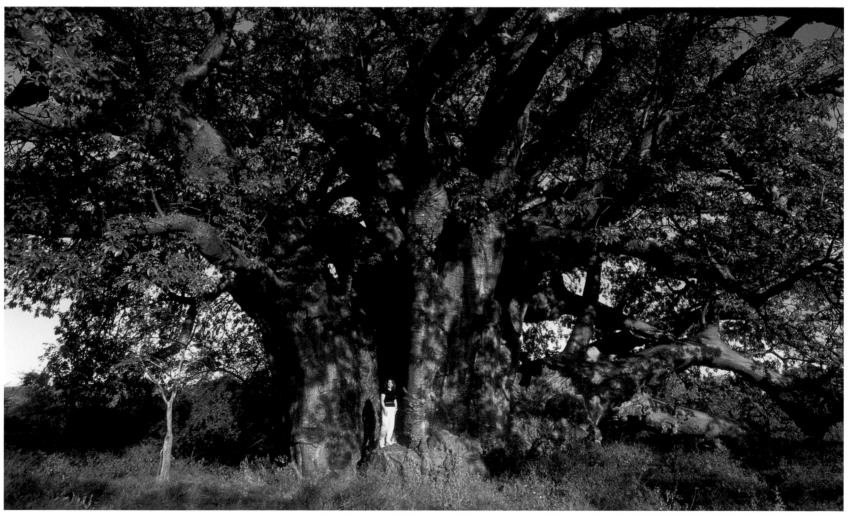

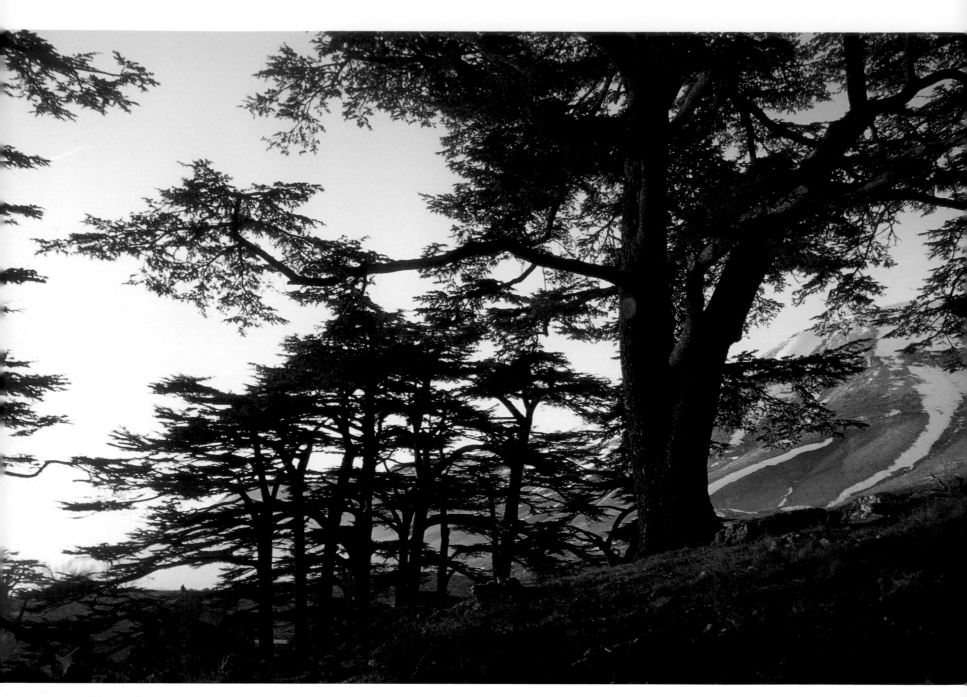

Cedars in Lebanon
Corfield medium format camera, 1/15th sec at F16

In the UK I have different times of year when I head out to take tree photographs. For one book I thought it would be good to get images of trees in different seasons to add interest. In the winter I avidly watch the long range weather forecast and gamble on snow arriving in places with great trees. On one occasion I could see snow heading for the borders of Scotland and I set out just before the snow fell so I could be close to where I needed to be for photographing the next day. It was a little tricky driving to the remote farm where the tree grew but the results were great. One of the things I hadn't planned for were the rather aggressive rams that shared the field with the tree. Happily, their inclusion improved the photo but I had to hop over a wall when they ran at me.

Planning to photograph the cedars of Lebanon in Lebanon required much thought and organisation. Only a tiny fraction of the once extensive cedar forest survives in the Middle East today and the oldest trees are to be found high in the Bcharre Valley in Lebanon. Until I had carried out research, I had no idea of just how harsh the winters were in that part of the Middle East. The mountains in Lebanon can be just as bitterly cold and covered in deep snow as areas of the Alps. As a result , skiers and ski resorts are one of the threats to this beautiful tree's regeneration. Luckily, I had a contact in Lebanon who briefed me on the weather conditions and as a result I decided to travel out to photograph them close to Easter, when the lower trees were snow free but the higher ones still had a snowy backdrop. This allowed me to take images that appeared to be in different seasons.

Expert tip

If you want to photograph autumn colour in the USA, check out the various websites that plot the likely dates when the displays will be at their peak in the various states. Some of the national parks also have live webcams, so you can see how the season is progressing.

The Hindenberg lime in Bavaria, Germany
Canon EOS 1n, 135mm F2L, 1/125th sec at F2.8

Fall in New England
Canon EOS 5D, 135mm F2L, 1/250th sec at F2

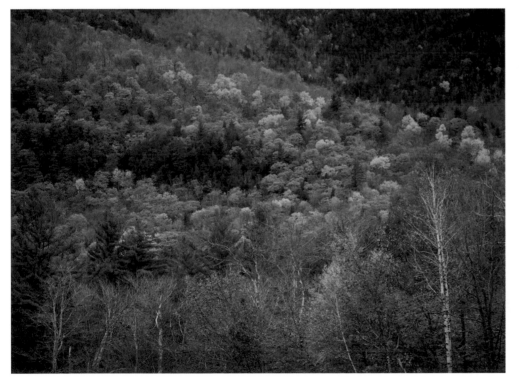

Another example of good planning was when I needed to photograph some of the greatest limes in Europe in southern Germany. I managed to not only locate where the best trees were but even a hotel that looked out over one of the trees. This meant I was ideally located when the weather conditions were perfect. I chose to go in May because of the new leaves and also because of the traditional May Day celebrations that happen around lime trees in Germany.

Autumn in eastern USA is one of the world's great natural spectacles. However, the forests cover such a huge range of latitudes that you need to be aware of when colours are likely to be at their peak in the various areas. It is possible to start photographing the autumn colour in the north near the Canadian border in early September, while in parts of Virginia and further south it could be at its best in mid-November. Planning is everything.

Throughout the year in the temperate parts of the world the opportunities for tree photography change with the seasons. It doesn't matter where you live, because there are often great possibilities even in major cities. The photograph below is taken in a park in London in late August. Gardens, parks and arboretums, such as the Royal Botanic Gardens, Kew, with their collections of exotic trees from all over the world, are great places to head for autumn colour or spring blossom.

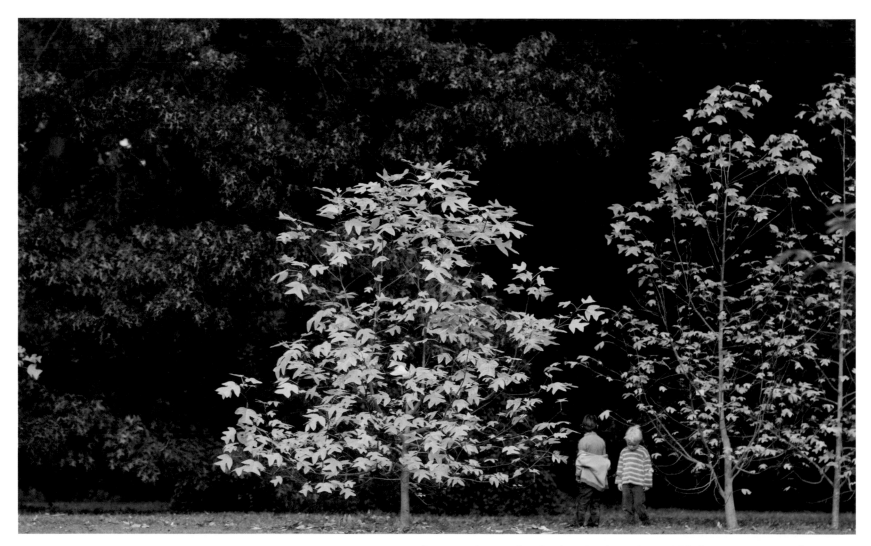

Autumn colours at Kew Gardens, London *Canon EOS 7D, 135mm F2L, 1/250th sec at F2.8*

I took this image at the Royal Botanic Gardens. It's one of my favourite places to see autumn colours and I know that I will be able to see a wide range of British and exotic trees. The main thing I look for is good weather conditions and plan my trips around that. The colours of the trees are fantastic, but here I was demonstrating how important backgrounds can be. If, say, the yellow or the red tree had been set against a white sky, the colours would have looked much more muted and indistinct, but by finding an angle with a shady background the foliage leaps out of the photograph. The inclusion of the children for scale also helps the image, as does the use of a telephoto lens to compress the perspective so it looks more like a wall of colour.

In the spring in the UK I am always ready to head to the woods to take photographs of one of the UK's great natural spectacles – bluebells. Bluebells blanketing the forest can really add to a spring image of woodland and there are numerous websites that can help you find out when they are at their best.

The photograph overleaf is currently one of my favourite winter images and was taken just a short distance from my house. Despite the cold, I headed out with my cameras, as the air frost and heavy mist offered the potential for creating a great winter scene. In the end, the image I took was beautifully simple – a frosted oak tree in the mist. It almost seems to be

Bluebells in coppiced woodland, Dorset, England
Corfield medium format camera, 1/8th sec at F16

Bluebell wood in Dorset, England
Canon EOS 1v, 28–70mm F2.8L, 1/8th sec at F16

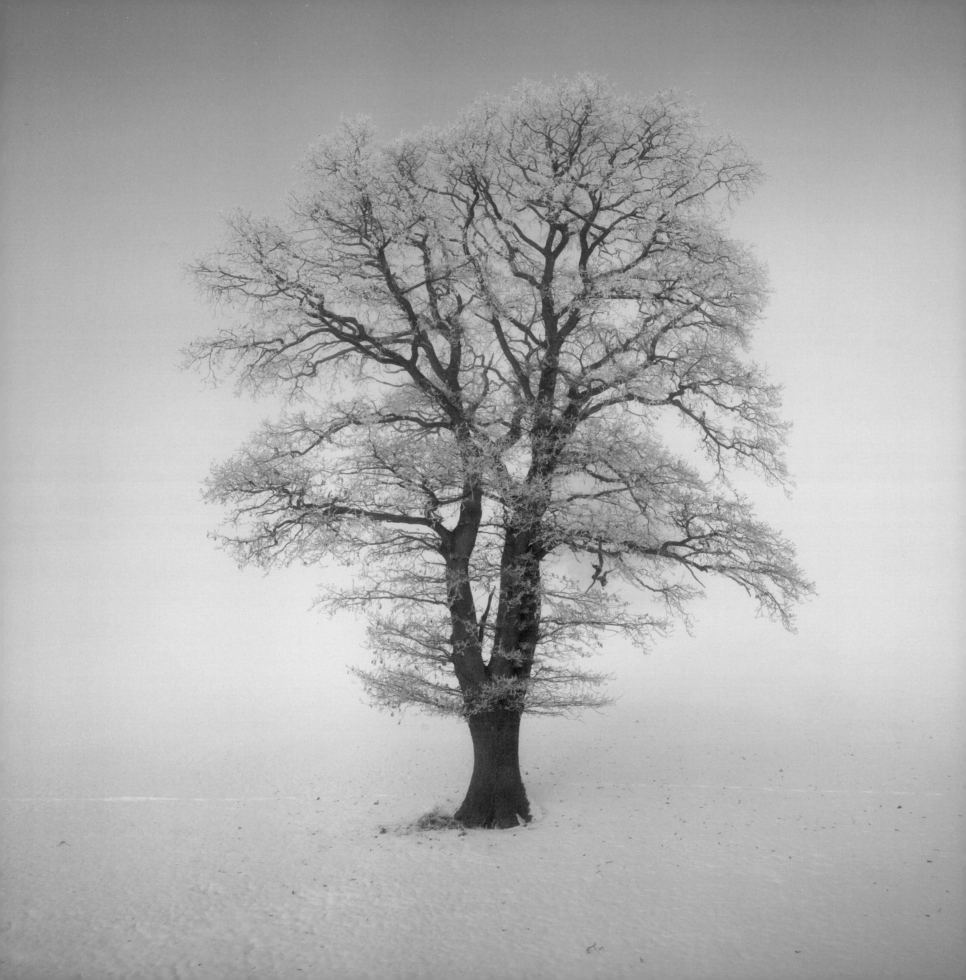

floating in space. I left lots of room around the tree to make the photograph more saleable. There is space above and below for a title and sub-titles. It can also be cropped in a variety of ways – square, tall and thin. – which gives designers a lot of flexibility, making it more likely to sell.

As part of my work I have to think what sort of final image I want and how it is likely to be used. Once I have identified the image I am looking for I start doing background research, on say a particular tree or forest. The decision process that I enter into goes something like this:

1. What do I need the image for?
2. What is the subject that I am looking to photograph? – let's say as an example a cedar of Lebanon tree.
3. Do I know how to recognise a cedar of Lebanon tree?
4. Where can I find examples of big cedars of Lebanon tree? Are there examples here in the UK in parks and gardens? In which countries are there wild populations?
5. Is there any good reason why I should photograph it in a natural or wild setting?
6. Is the tree evergreen or deciduous? Evergreen trees can be photographed all year round but with trees that lose their leaves there will be times of the year when there are no leaves, or there is blossom or there are autumn colours.
7. Does it have any remarkable or outstanding features?
8. Is there any season that is more interesting because of fruit, flowers?
9. Is there any season when the weather either makes access difficult/easy or can provide dramatic opportunities for backgrounds?
10. Are the wild populations in areas that are logistically difficult/easy to get to? All the time? In winter/summer?
11. Will I need any special camera gear? Should I hire a telephoto lens etc.?
12. Can I drive or will I have to walk a long distance to get to the location of the tree?
13. Are there any health and safety problems that I need to be aware of? The weather in mountains can change quickly. Animals such as bears might be present.
14. What sort of lighting or weather conditions help make for a good photo?
15. Will I need a guide?
16. How much time will I need?

ON THE DAY

1. What camera equipment will I need?
2. Are the batteries charged?
3. Do I have enough memory (flash cards etc.) with me?
4. Are my lenses clean?
5. What is the weather going to be like?
6. Do I need any special clothing?
7. Do I need any permissions?
8. How far will I have to walk?
9. Do I need a guide or information to identify tree species?
10. Are there any particular hazards to consider?

An oak tree in Cumbria, England taken in freezing fog
Canon EOS 5D, 16–35mm F2.8L, 1/8th sec at F11

HOW TO TAKE CONTROL OF YOUR CAMERA

This part is for those of you who would like to take more control of your cameras and lenses and make your own decisions about what settings are need to take a great image. However, it is not essential for a photographer to make every decision that goes into a photograph but it is useful to know when to control particular settings for particular effects. For example, may be you would like to take a scene in which almost everything is in the photograph is in sharp focus. In this case being in charge of the aperture that is being used is essential. However, using the 'aperture priority' setting, as in this example, means that the camera will still chose the shutter speed for a correctly exposed photograph and so on.

The chapter builds thorough understanding how to take control of settings such as exposure, focus, aperture priority, shutter priority and flash, all of which can have a bearing on the quality of the photograph. Here, instead of the camera making all of the decisions, you decide what are the most important decisions to be made and what the best compromise will be to ensure best photo possible. For example, on many cameras you can leave your camera on 'auto ISO' which means that the camera will automatically adjust the ISO (sensitivity) without regard for the quality of the final image. Setting your own ISO is one of the ways of determining the quality of the final image produced. Similarly, leaving the camera to focus where it deems appropriate can also lead to disappointing results.

The final part will then show you how to set up your camera to get the highest quality images with whatever equipment you happen to own. Often the very highest quality settings are not possible because of conditions such as low light levels or a fast moving subject in the image but in this section I will outline some of the compromises that need to be reached for the best results.

I have based what follows on my years of experience photographing in a whole range of conditions. Photography often boils down to making a number of decisions to reach the best compromise for the circumstances.

TAKING CONTROL OF EXPOSURE

Digital cameras are wonderful machines. They can do so much, and calculating exposures is one of the things they excel at. Coupled with this, and unlike a slide or negative film from a decade ago, the digital file can be adjusted quite easily in post-processing to get the required exposure if an error has been made. However, this is not without consequences and in our quest for the very best quality results, it is worth noting that any later adjustments to the exposure can cause a small loss in quality, and certainly any large changes can degrade an image quite noticeably.

Every exposure made by you is made up of a combination of an aperture and a shutter speed which determines how much light will be permitted to reach the sensor. The aperture is the iris in the lens, which operates in a similar way to the pupil in the human eye – it can widen to let more light through the lens or contract to reduce the amount of light that enters the lens. The wider the aperture the more light passes through the lens and the smaller the aperture the less light passes through the lens, if the duration it is open remains the same. These generally range from F2.8 to F32 in most general-purpose lenses, with the smaller numbers indicating the larger apertures, The shutter is the curtain in front of the sensor that briefly moves aside when you depress the shutter release, allowing light to reach the sensor in order to create an exposed image. Every shutter increment either doubles or halves the amount of light hitting the sensor. For example, a setting of 1/60th of a second lets in twice as much light as 1/125th, but half as much as 1/30th of a second if the ISO setting and aperture setting remain constant

There is a third factor in determining exposure which is the 'Sensitivity' (ISO). This is where the sensor's ability to respond to light can be increased. Most DSLR cameras and many compacts have a range of sensitivities spanning at least ISO 100 to ISO 6400. The

Hawthorn tree in blossom near Belfast, Northern Ireland.
Canon EOS40D, 135mm F2, 1/250th, F4, multizone metering (-2/3EV)

Expert tip

It is always worth bracketing with sunset scenes, especially when there are simple silhouettes in the foreground, because underexposed images can help saturate and enhance the stunning colours.

higher the sensitivity (and the higher the ISO number), the more sensitive to light the sensor is and therefore the less light is required to make an image. This is very useful in low light conditions, where you may need a higher shutter speeds to freeze motion or just eliminate camera shake. Once the ISO is set, the aperture and shutter speed are directly linked. However, the compromise is that the higher the ISO setting, the more potential problems the final image may have with 'noise' and the more degraded the image becomes compared with the optimum ISO setting. In an ideal world it would be best to always have the ISO setting at its lowest and therefore highest quality for all tree photography

EXPOSURE MODES

It is useful to understand the exposure modes on your camera as you will have to use one of them every time you use the camera. The job of all the exposure modes is to let just the right amount of light onto the sensor to register a correctly exposed image using a suitable combination of aperture and shutter speed.

There are four main exposure modes on most cameras: programme, aperture priority, shutter priority and manual. 'Program' is where the camera chooses both shutter speed and aperture for you and is ideal for point and shoot photographs and when 'grabbing' an image. Aperture priority is where you choose the aperture, enabling you to be in charge of how much of an image is in focus, and the camera selects the appropriate shutter speed to get a correctly exposed image. Conversely, 'shutter priority' is where you choose the shutter speed, for fast moving subjects or if you would like some blurred movement, and the camera sets the appropriate aperture for the correct exposure. And, finally, full manual where you set both aperture and shutter manually and the camera indicates when the combination will expose an image correctly.

Line of trees in snow in Cumbria, England. This is a classic example of where a camera's exposure meter can get confused. Most meters are set up to average the exposure in a scene so that it is equivalent to a mid-tone grey. When a scene contains a lot of white, then I find it's often best to overexpose by one stop (so move the exposure compensation to +1). Alternatively, I could set my camera on auto bracket and one of the three images it takes will usually be perfect.
Canon EOSS 40D, 135mm F2L, plus 2 x converter, multizone metering (+1EV)

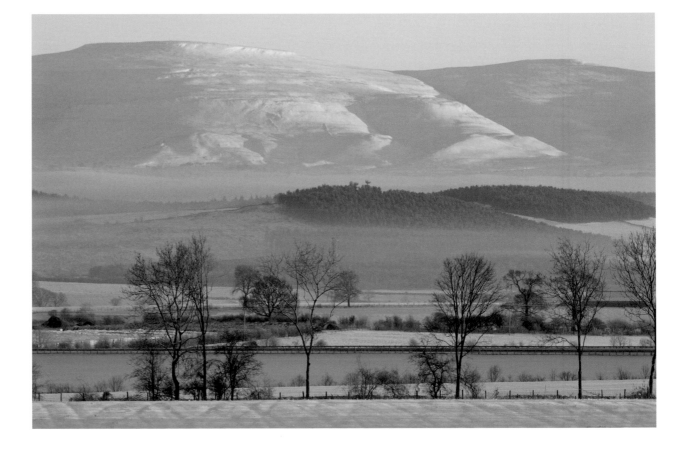

METERING PATTERNS

In more advanced cameras there are three main types of metering patterns – multizone, centre weighted and spot. This means that you can choose where in the scene will be the priority for the camera to expose for. Multi-zone metering is a sophisticated system that works by effectively dividing the scene into a number of zones, taking a separate reading for each zone and working out the best compromise. It is an incredibly reliable system and the one I use almost all the time. Centre weighted metering means that the cameras exposure sensor gives a higher priority to objects in the centre of the scene, ignoring areas of highlights or shadows at the edges of the frame. Finally there is spot or partial metering which when you want to take a meter reading from a specific point in the scene. The spot meter area only covers a small percentage and is best used by aiming it at a mid-tone in a scene, preferably grey, although browns and greens will work too.

The interesting thing is that most photographers tend to have the favourite meter pattern setting and use it almost all the time so it all comes down to preference.

EXPOSURE COMPENSATION AND AUTO-BRACKETING

The way to avoid this problem of under- or over-exposure is quite simple – just get an image with the right exposure to start with. This might sound trite, but I mean simply take several photographs of the same scene but with different

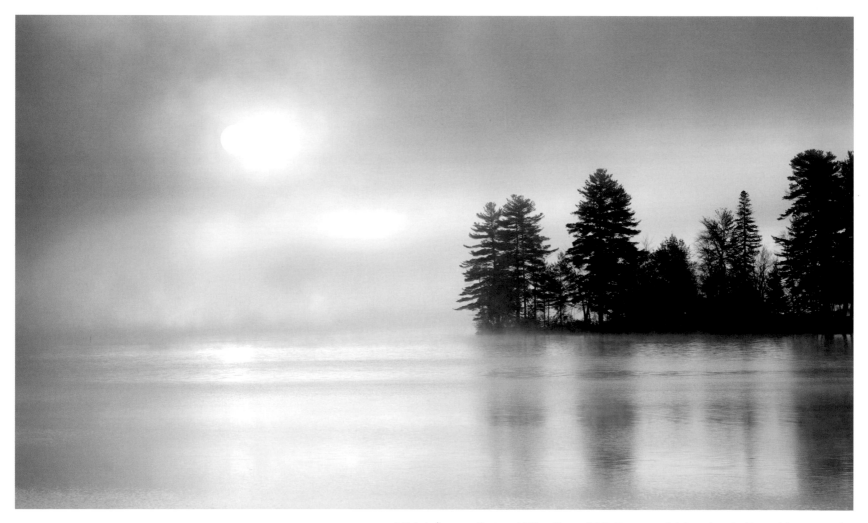

Misty Lake, near Boston, USA *Canon EOS 5D, 135mm F2L lns, 1/250th , F4, multizone metering*

exposures. This can be done very easily on most cameras by using the exposure compensation button. So, when taking, say, three photographs, take one at the camera's suggested best exposure and then one at +1EV (one stop overexposure) and another at -1EV on the exposure compensation dial (one stop underexposed). With these three different exposures, one of the photographs should be close to perfect in normal conditions. EV stands for 'exposure value'.

Your camera may also have an automatic exposure bracketing (AEB) setting. This allows you to select and set how much bracketing of exposure you would like, either side of what the camera is reading. The camera will then take three photographs at three different exposures automatically. It's a great feature for anyone worried about getting the correct exposure.

PUTTING IT INTO PRACTICE

Below is a scene taken using the exposure compensation facility, which has given me three images. I had a feeling that underexposure would work best on this New England landscape, so I took one exposure as suggested by the camera, another at one stop underexposed (-1) and yet another at two stops underexposed (-2). In the end, I preferred the one-stop underexposed image.

Choosing the multizone exposure setting has worked really well. However, don't get too hung up on exposure worries, as that can get in the way of concentrating on making a great photograph. Simply bracket (take different exposure settings of the same subject) which will pretty much guarantee a perfectly exposed image in most circumstances.

There are some situations, however, that can confuse the camera's metering system. In the image on p. 56, a beam of low-angled sunlight is shining on a hawthorn tree in blossom, while the surrounding green is relatively dark. With such strong contrasts, many cameras have problems calculating the correct exposure. With this in mind, I took three photographs with different exposures, and the underexposed one seemed to work best.

It is also worth noting that some cameras can get a bit confused if the whole image is predominantly green.

The photograph of trees in the snow on p. 57 is a classic example of where a camera's exposure meter can get confused. Most meters are set up to average the exposure in a scene so that it is equivalent to a mid-tone grey. When a scene contains a lot of white I find it's often best to overexpose by one stop (so move the exposure compensation to +1EV). Alternatively, I could set my camera on auto bracket and one of the three images it takes will usually be perfect.

1/250th sec, F5.6 Aperture priority and using the exposure suggested by the camera.

1/250th sec, F5.6 Aperture priority with exposure compensation of -1 EV

1/500th sec, F5.6 Aperture priority with exposure compensation of -2 EV

 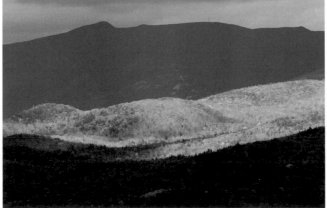 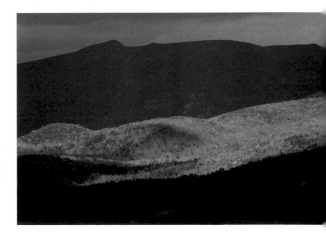

A view of the White Mountains, New England, USA *Canon EOS 7D, 70–200 mm F2.8L*

On p. 58 is a glorious lake scene from just outside Boston in northeastern USA. My first thoughts on the exposure I would need for this image, considering it contains large areas that are brightly lit, was that I would need to overexpose by one stop. However, because the trees are in silhouette, the average exposure worked best, because the pink dawn colours looked better saturated. Overexposure just made the colours washed out.

Every now and then I'm provided with a photographic opportunity that I know will really stump the metering system. In the photograph below, I was caught in a storm, with fantastic black clouds that slowly snuffed out the sunset I had been hoping to capture. Nevertheless, just before the massive black cloud hit the horizon, I managed to take a photograph of a strip of golden light sandwiched between the land and the advancing cloud. I bracketed to get the right exposure, but I knew with that amount of black I would have to underexpose. In the end, a full two stops (-2) produced the result I was looking for.

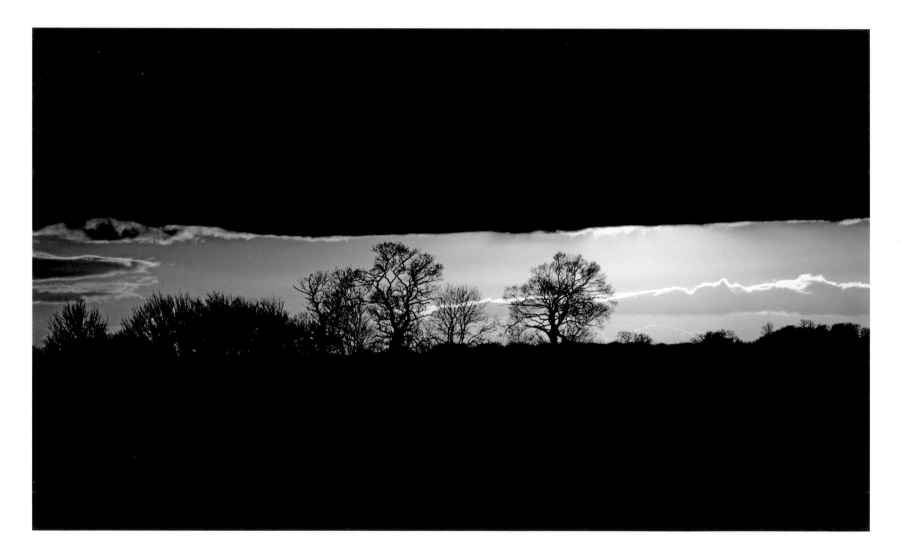

A storm at sunset in Suffolk, England
Canon EOS 1Ds, 300mm F2.8 L, 1/500th , F4, multzone metering (-2EV)

FOCUS

I am all for keeping life simple if I can, and autofocus systems are a real godsend in most situations. When photographing trees, you can be fairly confident that the camera will find the right point to focus on. If you are using a small aperture, this will make the autofocus even more reliable (because more of the scene will be in focus). However, it is useful to know when the camera might need some help with focusing, and when you need to take control.

I must admit to being a fan of technology that doesn't take over the photographic decisions altogether, but rather helps in areas where it is easy to make a mistake that could cost you a good photograph. That is not to say you can leave it to the camera to make the decision on which part of the scene to focus on in all circumstances.

Autofocus has come a long way since its introduction back in the 1990s. The first autofocus camera I had focused via a point right in the middle of the viewfinder, which was perfectly useless in many instances when composing using the rule of thirds (see Part One Composition). However, I ended up using it as spot-focus facility, by pointing it directly at the place I wanted to be in focus and then either switching the lens to manual (there is a manual/autofocus on button on the side of most lenses) or holding the shutter release half down and recomposing.

Central focusing is still a feature of only the most basic compact cameras now, but generally most medium-priced compacts and hybrids have a more sophisticated way of getting focus. On many DSLRs, this complexity is taken a step further, with a grid of little points visible in the viewfinder that light up whenever they are in focus.

The autofocus on most advanced compact cameras and DSLRs works in combination with the 'mode' selected via one of the buttons on the top or side of the camera. You generally have the choice between single-shot AF (AF-S), continuous AF (AF-C) or manual.

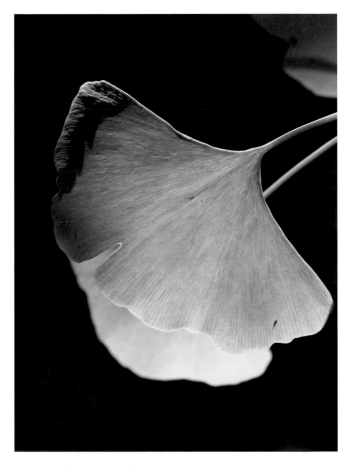

Close up of a ginkgo leaf at Kew Gardens, London
Canon EOS 7D, 100 F2.8 macro, 1/125th sec F4

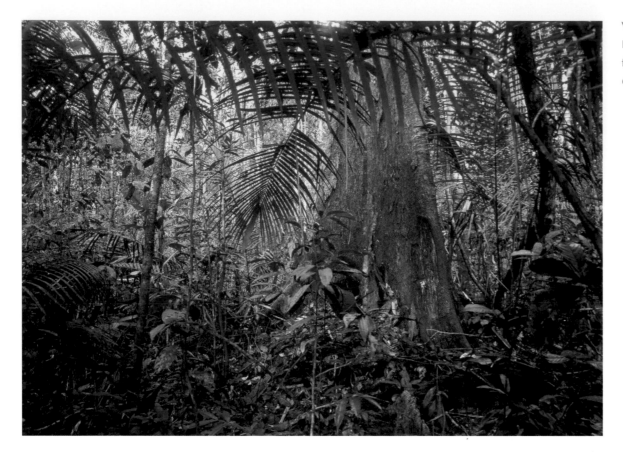

View of the interior of the rainforest near Manaus, Brazil. A scene like this is easy for all types of camera to focus on.
Canon EOS 1v, 20mm F2.8, 1/4 sec, F18

Generally, in single-shot (AF-S) mode, the camera focuses on a subject when you half depress the shutter release but won't take a photograph until the subject is in sharp focus. This is great for static objects like trees but may not be as reliable on a windy day.

In continous AF (AF-C) mode the focus will continually adjust whilst you have the shutter release half depressed and can be used for a fast sequence of images of a moving subject., Photographs are taken by positioning the AF point over your subject and by keeping the shutter release half depressed. In this setting the camera will take images regardless of whether they are in perfect focus, and set on continuous AF mode, the camera's computer follows the focus of a fast-moving subject by predicting its direction and speed to keep it reasonably sharp. This is brilliant for a bird in flight, for example.

In this section, my aim is to show you how to take control of your camera and take photographs exactly as you want them. So when using autofocus on multipoint AF – this is where the camera selects the focus point and highlights the grid points visible in the viewfinder to tell you which bit of the image it is focusing on – you can take the photograph when the points light up on the area you want in focus. Using the focus on single point AF allows you to be able to select which focus point on the grid visible in the viewfinder you would like to use, (usually using a thumb wheel on the back of the camera). For example, in portrait photography the eyes are the crucial part that needs to be in focus, so I twiddle the wheel until I have chosen the point that lights up in the viewfinder that falls on one or other eye. Using the selective focus approach you can be in charge of what is in focus and what isn't.

Trees generally don't run about too much, so you should be able to calmly find what you think is the most important area to be in focus before pressing the shutter. In a lot of circumstances in tree photography, the autofocus set up of the camera is perfectly adequate.

However, I've chosen the image opposite to demonstrate a scene that might confuse an autofocus system. The camera tried to focus on the moving water, so I chose a focus point that fell on the roots on the right, about one-third of the way into the scene.

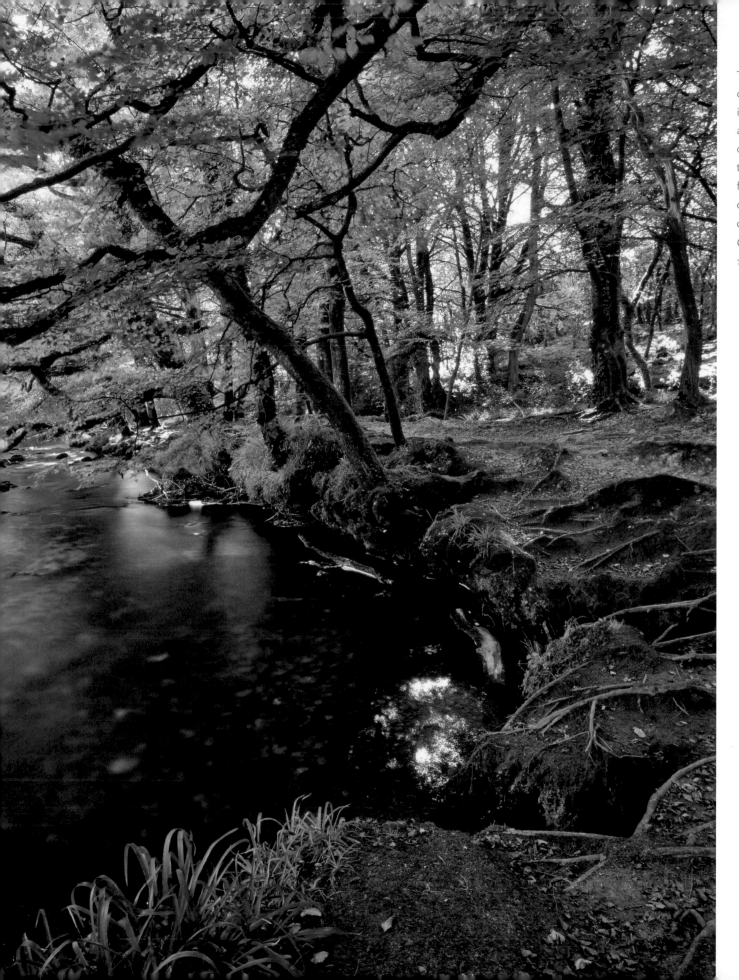

This riverside scene of trees on Dartmoor, Devon, England is another that might confuse an autofocus system. An area of moving water can confuse the autofocus, so I chose a focus point that fell on the roots on the right, about one-third of the way into the scene. *Canon EOS 1n, 20 mm F2.8, 1/4 sec, F22 (on tripod)*

Rows of tree guards in snow
Canon EOS 1Ds, 16–35 mm (at 20 mm) F2.8L, 1/30th sec, F16

The image on the left demonstrates a technique using what is known as the hyper focal point. This is the point in a photograph to focus on that will give the impression that just about everything is sharp. In earlier chapters, I explained how using a wide-angle lens and a small aperture is a great way to get most of a scene in focus (or create a large depth of field), and here I used a wide-angle zoom at 20 mm, with the aperture at F16.

Looking through the viewfinder, I chose to focus on a point about one-third of the way into the scene. This is based on the knowledge that the focus at F16 will be sharp both in front and beyond the point of focus. At the same time, I know from how the brain scans a flat object that if this part of the image is sharp, then the brain can be tricked into thinking that the rest of the image is sharp too (when it may not be).

It is possible, but not guaranteed, that the autofocus on my camera would have chosen the correct point to focus on too. Interestingly, though, even at F16 and with a wide-angle lens, if the camera had focused on the very first tube or the tree in the background, then parts of the photograph could have been out of focus.

The soaring hawk opposite is another scene where a camera's autofocus system can have difficulty finding a point on which to focus. Autofocus requires good contrast in order to function correctly, but here the contrast has been reduced due to the smoke from a fire. In such circumstances, you can often hear the autofocus whining as it tries in vain to get sharp focus. To overcome this problem, I selected a single point on the grid in the view-finder (the central ones are generally the most sensitive) and aimed it at a tree silhouetted against the sky. Once I had what I thought was sharp focus, I then turned off the autofocus (using the little button on the side of the lens marked M and AF) and recomposed the picture. I could then happily photo-graph the scene without having the autofocus continually hunting for focus. It also saved on battery life, in a place a long way from electricity.

Expert tip

You can point your camera at what you would like to be in focus (by selecting the point on the grid in the viewfinder) and then, to save battery life, you can switch off the autofocus by using the button on the side of the lens barrel marked M-AF.

Backlit beech leaves in Dorset, England
Canon EOS 1Ds, 135mm F2L, 1/250th sec, F4

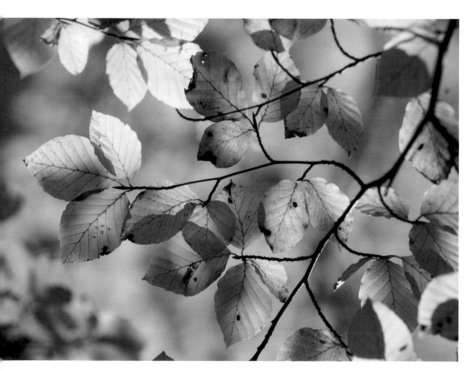

More backlit beech leaves in Dorset, England
Canon EOS 1Ds, 135mm F2L 1/250th sec, F4

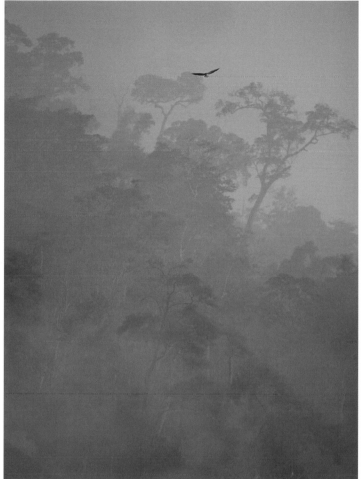

Hawk soaring over the Atlantic Forest, Brazil
Canon EOS 1v, 300 mm F2.8L, 1/50th sec, F2.8

When photographing tree foliage, even a slight breeze can give you unpredictable results using autofocus. The two images of leaves, left, are taken with the same lens and at the same setting, both using automatic focus. As the leaves move around, the focus can change from foreground to background in an instant. Both images are perfectly fine, but if you want to choose the point of focus, aim the focus point at a particular leaf then hold down the shutter release half way to lock the focus. You can then recompose your image if necessar. You can also find the point of focus and switch the lenses' autofocus off in order to keep sharp focus. For those of you with good eyesight, you can switch to manual focus and just do it by eye.

USING APERTURE PRIORITY (A OR AV)

One way to take control of your camera is to set the camera to 'aperture priority' and be in control of making the choice of which aperture to select. Setting the aperture allows you to decide how much of your image will be in focus, otherwise known as the depth of field. Choose a small aperture if you want much of the image to be in focus, but if you want a limited amount of the image to be in focus with a blurred background and/or foreground, then select a larger aperture.

The aperture is the iris on the lens through which the light enters the camera. It works in much the same way as the human pupil in the eye, opening up when there is little light and becoming smaller when there are bright conditions. In tree photography aperture priority mode is the most popular because it allows you to determine how much of an image is in focus by controlling the size of the aperture. If you are looking for front to back sharpness then select a small aperture such as F11, F16, F32 especially with a wide angle lens. Conversely, if you would like only a shallow area to be in focus and the background blurred, such as when photographing a leaf, then simply select a large aperture such as F4 or F2.8 especially with a telephoto lens.

To take control of the aperture, you need to set the dial on the top of the camera to aperture priority,(A or AV). Then, whichever aperture you select, the camera will automatically set the appropriate shutter speed to give the correct exposure. As I have mentioned before, everything to do with photography is about compromise. When you select an aperture, the compromise is that the camera may not choose a shutter speed you want – it may be too slow to hand-hold the camera without shaking, or the subject may be moving too fast to be frozen in movement. The smaller the aperture, the longer the exposure has to be if the sensitivity remains the same.

Wild service tree in Hampshire, England
CanonEOS1 Ds, 16–35 F2.8L 1/60th sec at F5.6

Bristlecone pine trees and fallen timber *Canon EOS 1n 20mm, F2.8, 1/30th sec at F4*

Monkey puzzle foliage at Kew Gardens, London, England
Canon EOS 40D, 100 mm macro, 1/125th sec, F4

Monkey puzzle foliage at Kew Gardens, London, England
Canon EOS 40D, 100 mm macro, 1/125th sec, F5.6 (with fill-in flash)

Expert tip

To work out the slowest shutter speed at which you can hand-hold a shot (without using image stabilising), take the focal length of the lens (or setting on a zoom) and turn it into a fraction (of a second) by putting a 1 above it. So, with a 135 mm lens, you should get a sharp photo at the closest shutter speed to 1 over the focal length, i.e. 1/125th of a second. A 20 mm wide-angle lens, on the other hand, can be held reasonably down to 1/30th or even 1/15th of a second.

With tree photography, the solution is often to use a tripod. This can make the final shutter speed irrelevant (if there is no wind moving the leaves). So I could choose an aperture of F22 to get the most of the scene in focus, and the camera might select a long shutter speed of 13 seconds at dusk to achieve the correct exposure, but without any wobble from hand-holding the camera and with no movement in the tree, a completely super-sharp photograph should be possible.

Finally, how wide angle or how telephoto the lens you are using also affects how much of an image it is possible to get in apparent focus. For example, choosing a slightly smaller aperture of, say, F8 instead of F4 on a 300 mm telephoto lens may only make the background slightly less blurred, whereas with a wide-angle of say 20 mm lens the amount of the photograph that is in focus will be noticable.

Lens manufacturers normally identify their lenses by both focal length and the largest aperture available, so a 300 mm F2.8 lens has a final aperture of F2.8 and the chance of using much bigger apertures than, say, a 70–300 mm F5.6 zoom.

Just to complicate matters a little more, in this digital era the size of the sensor also has a bearing on how much of a photograph appears in focus. I have often looked jealously at a photograph taken with a compact camera that appears to have produced an image where everything is in focus. On a camera with a full-frame sensor using the same aperture, it would not have been possible to get so much in apparent focus. However, the bigger the sensor, the more blurred you can make the background, which is something that compact camera users are often unable to achieve. Compromise again. (For more on sensors, see the Introduction – Cameras).

If you're using a compact camera it is often difficult to get an image with a good blurred background so your best bet is to use the longest focal length (telephoto setting) on your zoom and the largest aperture and focus on a close object

With the two images of monkey puzzle leaves here, similar settings have been used for both. In the one above left, because the subject is not perpendicular to the front of the camera, the large aperture is only able to sharply record a tiny part of the whorl of spiky leaves.

But if you photograph the leaves from a different angle, as in the image far left, you can get most of them in sharp focus using a similar setting.

When I first started out in photography, I was intrigued to look at images from *National Geographic* magazines that were seemingly in focus from the front to the back of the image. I have subsequently learnt how to combine lens aperture and point of focus to get the best results.

When photographing this monkey puzzle tree growing in a volcanic ash field, I wanted everything to appear in focus. So first I selected a wide-angle lens, as these generally get more of an image in apparent focus than longer focal length lenses. Then I chose an aperture, bearing in mind that I had to hand-hold the camera. Fortunately, there was enough light to let me use a 1/30th second exposure at F16. Finally, I chose what is often referred to as the 'hyper focal point', which is the point of focus at which the brain is tricked into thinking that more of an image is in focus than it actually is. Generally it is about one-third of the way into the image. In this case, I focused on the most prominent boulder in the foreground.

Had I been using a compact camera with a small sensor, I could have probably achieved the same result simply on program mode and not worried about apertures so much.

When a tree is a good distance from the camera, the aperture becomes less of an issue, as everything effectively becomes close to infinity and so everything that is beyond that will appear reasonably sharp. In the photograph opposite, I wanted to show a monkey puzzle forest in Chile in a way that implied its great evolutionary age, as they existed before the dinosaurs.

Monkey puzzle tree on an active volcano, Chile
Canon EOS 1n, 20 mm, 1/30th sec, F16

Monkey puzzle tree on an
active volcano, Chile
*Canon EOS 1n, 135 mm F2L,
1/250th sec at F2*

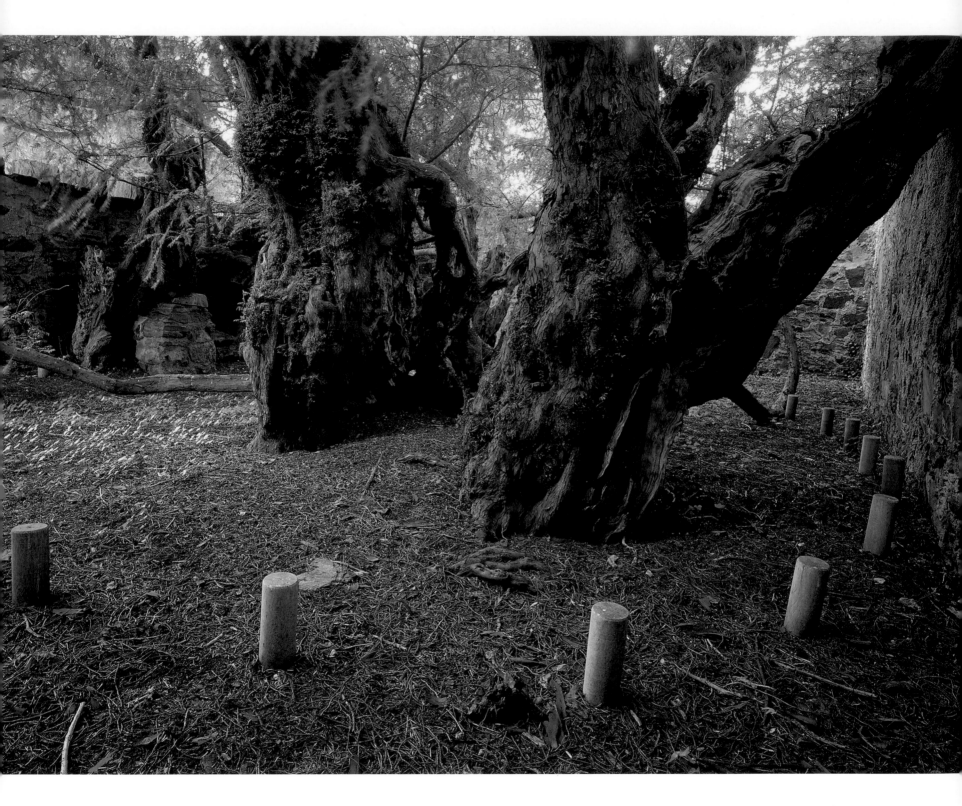

The Ancient Fortingall Yew, near Aberfeldy, Scotland *Corfield 6x8 camera, 21 mm (35 mm equivalent), 1/4 sec, F32*

African boy with trees in school tree nursery
Canon EOS1n 135mm F2L, 1/125th F2

The fog/low cloud gave a wonderful prehistoric-feeling backdrop – so much so that I was brought in by the BBC for background location advice for the series Walking with Dinosaurs. Because of the low light levels, I was forced to shoot at 1/250th of a second at F2 on a 135 mm F2L lens. Even so, there is enough detail in the trees behind for them to be recognisable.

The photo above demonstrates an aperture and lens combination that makes the background blurred and helps the child be the focus of the image. The photo was taken at a school in Tanzania where the headmaster had a scheme where every child planted and tended several trees during their education at the school. In doing this they not only gained an understanding about planning ahead and sustainability but also had the timber they needed for the supports of their first house.

Expert tip

If you want a blurred background, you need a large aperture, but this also gives a small depth of field, meaning that only the very smallest part of the photograph will be in focus. When photographing a leaf, if you position yourself so it is pretty much perpendicular to front of the camera, it should all be in sharp focus because most of the leaf remains the same distance from the camera and therefore in focus.

SHUTTER

Ginkgo leaves blowing in the wind in Seoul, South Korea
Canon EOS 1v, 135mm F2, 1 sec, F4

Expert tip

When using a long shutter speed it is easy to wobble the camera when depressing the shutter release, even on a tripod. It is best to use a remote release or, failing that, simply set the timer on a two- or ten-second delay, press the shutter release and by the time the photograph is taken the vibrations caused by depressing the shutter release will have ceased.

Shutter speed, in my opinion, is a much less important consideration than aperture and quality (ISO setting) when photographing trees. By this I mean that generally trees don't jump up and down and need to be frozen in motion. They can, however, move quite substantially in the wind (which can be both a problem and, occasionally, an asset). In this situation, it's often best, if you can, to simply come back on a calm day to get the desired photograph. That said, it is useful to know how and when to take control of shutter speeds, as coming back another day is not always an option. To select shutter priority mode set the camera to Tv or S on most camera makes.

Creating the image on the left gave me an interesting dilemma. I was only scheduled to be in Seoul for a day, but a strong wind was making the ginkgo trees I had come to photograph dance and move about. Not only that, but it was grey and overcast, so it was difficult to get fast shutter speeds that would freeze the motion unless I used very high ISO settings, which I tend to avoid as they reduce the image resolution. Eventually, I decided to set up a tripod and selected varying slow shutter speeds to record the movement. I was happy with the final result, which conveys the swirling movements of dancing reminiscent of the 'dragons' seen in Chinese New Year festivities. And the image ended up being published across a double page.

When you select the shutter priority mode, you can choose whatever shutter speed you want and the camera will automatically select the right aperture to get a well-exposed photograph. However, do check in the viewfinder, because if the shutter speed you select requires an aperture setting beyond the range of the lens, you may see a flashing warning. For example, if you were to use a long exposure and point the camera towards the sun, the corresponding aperture required may be more than F22 or F32, which are generally the

Squirrel in Hyde Park, London England
Canon EOS 1Ds, 135 mm F2L, 1/250th sec, F2.8

Bounding squirrel in Hyde Park, London, England
Canon EOS 1Ds, 300 mm F2.8 with 1.4 converter
(effectively 420 mm F4 lens), 1/1,000th sec, F4

smallest apertures available on most lenses. The same is true when using a fast shutter speed on a dark subject. The lens may have a maximum aperture of F5.6, but the appropriate aperture to get a well-exposed photograph at a particular ISO setting may be beyond that, at F2.8.

One of the key considerations with slower shutter speeds is camera shake. This is the movement made by the person holding the camera when the photograph is taken and it causes a slightly (or substantially) blurred final image. In my experience, camera shake is an all-too-common problem

and it can greatly reduce image quality. A bit of sharpening in post-processing may be possible, but too much will end up degrading the image so it's best to get a shake-free image if at all possible..

Look at the two photographs of the squirrels. In the first one, my main consideration was to make sure I used a shutter speed that allowed me to hand-hold the camera and still get a sharp photo. As explained in the previous chapter on aperture, you can estimate the shutter speed at which you can hand-hold as shot by making a fraction of 1/focal length. In this case, the

Lime tree in Lake District
Corfield medium format camera, 13 secs at F2

135 mm lens could be held at 1/125th of a second, although I chose the faster setting of 1/250th for safety.

Then look at the bounding squirrel on p. 75. The same shutter speed would not have frozen the movement or been appropriate with the longer telephoto a 300 mm F2.8L with 1.4 converter (effectively making a 420 mm F4 lens). I calculated that I needed to have a shutter speed of 1/500th of a second or more to hand-hold the shot, but in the end used 1/1,000th to freeze the squirrel in mid-leap.

Aiming for the highest quality result when taking the photograph, below left, I used ISO100, but this left me with a shutter speed of 1/15th of a second at F2 on my 135 mm lens. This meant that I had to use a tripod to eliminate camera shake, and then wait for a moment when horse and man were not moving too much. Look closely and you'll notice the blurring of his hand and the horse's tail, but generally the shot worked well.

Opposite is a photograph that I consider to be almost perfect. It shows a lime tree in the Lake District. One of Europe's top lime experts estimates it to be 1,600 years old, and that for more than 1,000 years coppiced by people (cut to the ground every couple of decades so it produces straight poles for harvesting). In this photograph most of the conditions that I prefer to use in woodland photography combined beautifully. The overcast day meant I could photograph the tree from any angle and that the foreground and background would be evenly exposed too. I set up a tripod so I could choose the aperture for maximum depth of field (focus) and used a cable release to eliminate camera shake. There was a little breeze, but I waited for a moment of stillness before taking the shot. It was almost dusk and I used a 13-second exposure at F22. The quality is remarkable and the only evidence of such a long shutter speed is the slight blurring on one of the leaves and the fact that the movement in the water in the stream has made it look like brushed steel.

Below, the low shutter speed is good enough not to have camera shake but allows the blowing snow to blur which adds to the image.

Cork oak harvester, Andalucia, Spain
Canon EOS 1v, 135 mm F2L, 1/15th sec, F2

Snow blowing through a forest in South Korea
Canon EOS1n 28–70mm F2.8L 1/30th F5.6

Palm tree with trailing car lights, Naples, Florida
Canon EOS 1Ds, 16–35mm F2.8L, 4 sec, F22

I like using some movement in my tree photographs for added interest, especially in urban situations, as in the two images on this page. In the first, I liked the lights on the palm trees and, because the road never seemed to be free of traffic, I used a long exposure to get the trails of the lights of the cars moving through the scene. Look at the tops of the palm trees and note the blurring. This was because the fronds moved in the wind during the exposure, which was not ideal.

I used a similar technique in the photograph below of an ancient oak in the centre of London. Here, even if the wind had been strong, the sturdy, squat nature of the tree would have had little movement to affect the final image. I was using exposures of around 4–8 seconds and trying to time the shutter just as cars entered the frame. When taking night photographs, I like to time it so there is just a little light left in the sky, as the trees stand out better.

Oak in a London street, England
Canon EOS 5D, 16–35 mm F2.8L, 6 sec, F22

FLASH

Ancient Yew in Wales
Canon EOS 1Ds, 28–70 F2.8L, 1/15th sec, F4 (fill flash and tripod).

Although I use flash quite a bit in general photography, I tend to steer away from it in most tree photographs. Nevertheless, it is a technique worth discussing, albeit briefly. The main times I use flash in tree photography is with people working in a forest or in macro photography of leaves and flowers. It is possible, however, to use flash on whole trees, but generally I like to use natural light wherever possible.

I tried using flash on this ancient yew in Wales, but the result was a bit disappointing. It would have been much better if the flash had been away from the axis of the camera, but this would have meant using techniques to remotely set off the flash. As it is, the tree looks almost like a cut-out against a rather disappointing sky.

Where flash really comes into its own, I find, is when photographing people at work in woods and forests. Look at the photograph overleaf of these cork oak harvesters – the deep shadows and brilliant patches of white on a bright day in the middle of August could have spoiled this image, but my use of 'fill-in flash' has illuminated the people close to the camera perfectly. The term fill-in flash refers to the way the flash helps to fill in, or show up, the details in parts of the photograph close to the camera that would otherwise have been in deep shadow while still exposing correctly for the background.

This effect can be achieved generally on the program mode, and with compact cameras on the auto setting. It is also possible for advanced photographers to achieve the effect using aperture, shutter priority or full manual. This is because the flash (either the on-camera pop-up type or a separate flashgun) is generally designed to send out enough flash to get a good exposure for whatever aperture is set, irrespective of shutter speed. The only things that needs to be considered are the synchronisation of the flash and holding the camera still enough so the background isn't blurred. Generally the flash synchronisation is only possible up to certain maximum shutter speeds, such as 1/60th of a second, more commonly 1/125th of a second and sometimes as high as 1/250th of a second on more advanced

Cork oak harvesters, Spain.
Canon EOS 1v, 28–70 mm F2.8L, 1/30th sec, F4, with fill-in flash (-1EV)

Lime-tree blossom, England
Canon EOS 1Ds, 100 mm macro F2.8, 1/125th sec, F11 (with flash)

Teak tree plantation, Java
Canon EOS 1v, 16–35 mm F2.8L, 1/60th sec, F6.7 with fill-in flash

cameras. If you try to take a photograph at a shutter speed faster than the suggested maximum, the flash won't register fully.

An interesting thing about fill-in flash shots is that sometimes the areas of fully exposed fill-in flash can rather dominate the photograph. As a rule of thumb, it is better that the flash output is one stop underexposed to give a more natural feel. Although many of today's cameras do turn out well balanced results there is a facility on more advanced compacts, DSLRs and sometimes even on the flashguns themselves to use exposure compensation, just as you would for a normal exposure. On some of the more expensive flashguns, there is even an auto-bracketing feature, which will take three photographs in quick succession, each with a different flash exposure. This enables you to alter the power and exposure of the flash. If the flash is too bright in the foreground it is possible to underexpose by a stop or two (-1 or -2) until you get the desired balance of flash and background exposure.

I also use fill-in flash on small trees, especially when there are deep shadows, such as with this young teak tree. Look at the trees in the background and you can see that at the angle I chose to photograph I would have got a virtual silhouette if I hadn't used fill-in flash.

Using specialist macro flash on flowers, such as the lime above, can really help in adverse weather conditions. It is even possible to shoot flowers and leaves at night, and you can use the flash pulse to freeze the movement of leaves and flowers blowing about in the wind.

Golden lion tamarin monkey in the Atlantic forest near Rio, Brazil. I use fill-in flash sometimes when photographing forest and woodland wildlife. In this photograph I was following a scientist at work in the Brazilian rainforest who was researching golden lion tamarins. There are only around 2,000 left and they are gravely endangered due to deforestation of their habitat and their endearingly friendly nature. Here I used a 135 mm F2 lens at its widest aperture under the dense tree canopy, but a pulse of fill-in flash, set at one stop underexposed, really lifts the colours of this beautiful monkey.

Canon EOS 1v, 135mm F2L, 1/125th sec, F2, fill flash -1EV

IMAGE QUALITY

If you go to all the trouble of seeking out a great tree to photograph and composing a beautiful image, then it's worth making sure that the quality of the final result is as good as you can make it. Maybe you want to enter your photograph into a competition, blow it up into a giant print or calendar, or even get it published. Whatever your aim, it is useful to understand some basics about image quality.

With every photograph you take, you always have to choose between a series of compromises. In a perfect world, the highest quality image possible on whatever camera you own is determined by the size and quality of the sensor, the number of pixels, the sensitivity setting (ISO), the quality and setting of the lens, the amount of camera shake and the amount of movement in your subject. The wonderful thing about tree photography is that there will be situations when it is possible to get the very highest image quality that is possible with your equipment, so even if your camera and lens are quite modest you should still be to able to achieve images that rival that of professionals.

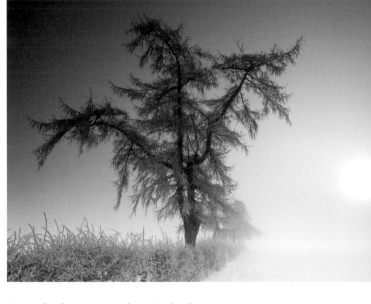

Frozen larch tree in Cumbria, England
Canon EOS 5D 16–35mm F2.8L, 1/15th sec, F11

HOW TO GET THE BEST QUALITY PHOTOGRAPH WITH YOUR EQUIPMENT

The ideal scene may be a tree standing isolated on a hill or in a landscape on a windless day. To capture this perfectly, you should use a tripod (basic ones can be picked up for very little money), so you don't have to worry about having to use a fast shutter speed to eliminate camera shake, while the still conditions also mean that the shutter speed (to freeze movement) becomes irrelevant. This allows you to set the camera on its very finest setting (usually 80 or 100 ISO), so that the very maximum information will be captured, avoiding any problems such as 'noise' and 'pixilation' which can reduce the quality of the final image.

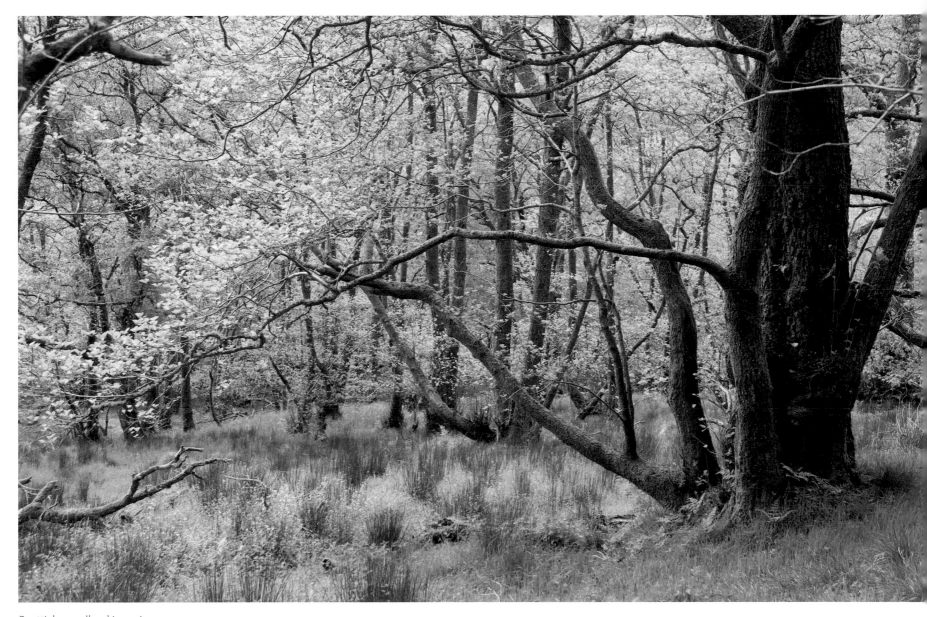

Scottish woodland in spring
Canon EOS 1Ds 28–70mm F2.8L, 1/15th sec at F16 (tripod)

Then select your sharpest lens and set it at its sharpest aperture. Bear in mind that lenses can be markedly sharper when not extended to their extremes of aperture or zoom. Therefore, set both the zoom and aperture towards the middle of their range for optimum quality. Finally, use a cable release or, failing that, a shutter delay timer to eliminate any possible camera shake, which can occur, even when using a tripod if the shutter is released by hand. In my experience as a photo tutor, camera shake is often the reason behind a poor photograph, rather than the quality of the lens or the sensor.

If you use all of these techniques, it's possible to get images that can be blown up to poster size from quite basic cameras.

A pine cone at Kew Gardens which could have been just as well taken on a compact camera as a DSLR
Canon EOS 5D, 100mm F2.8 Macro, 1/125th sec at F5.6

Red mangrove forest, Costa Rica
Canon EOS 70D, 135mm F2L, plus 1.4 converter, 1/250th F2.8 (ISO 500)

RAW AND JPEG

On basic phones and compact cameras, the image files that are saved on to the memory card are generally in the form of a JPEG. However, with some of the more advanced compacts, hybrid cameras, CCS and DSLRs, you have the option to save as either a JPEG or a RAW file, or both at the same time.

The advantage of using JPEGs is that these files use a clever compression system that means they take up far less space on the memory card and eventually on your computer than a full RAW file. However, the compressing and opening up of files can cause the image quality to deteriorate over time. One analogy is to consider what happens to a folded map and one framed behind glass over time. The folded map eventually begins to degrade, because the act of opening and closing it causes a little damage every time, whereas the same map framed behind glass remains perfect indefinitely. One way this can be reduced is to choose the JPEG setting on your camera with least compression. Generally you will have the option to choose 'high', 'medium'

and 'low' compression. The images taken on the JPEG with low compression will degrade very little and are similar in final quality to RAW files.

RAW files, on the other hand, which are converted to TIFFs, can be huge, occupying much more space on the memory card and computer. However, because the file is never compressed or expanded, it retains the maximum amount of information, however many times it is opened, adjusted and saved. RAW files also register slightly more information than a similar sized JPEG and suffer far less from problems associated with adjusting images, for example, to improve the colour balance or sharpness.

London Eye on damp winter morning, London, England *Canon EOS 1Ds 16-35mm F2.8L, 2 sec F16 (ISO 100 and tripod).*

With my camera I have the option of shooting in both JPEG and RAW simultaneously, which allows me to have the best of both worlds. I have the JPEG, which can be opened up on most basic laptops and is in a format that can be emailed if I have a tight deadline. At the same time I have a file that I can process later, which has the maximum information that can be recorded at those particular settings (ISO, lens quality, sensor size, etc.) and will not degrade over time.

My aim is always to produce a photograph that will sell successfully and possibly also do well in photographic competitions. So I want to record the maximum possible data on the file, which I do by taking a RAW image. That means the quality will be good enough for any eventual requirement, be that an exhibition print or a wall poster 4 m wide, which is what one of my tree images was recently used for, to hang in the foyer of the offices of an environmental organisation.

The down side of RAW files is that they can be less easy to handle as they require a particular RAW converter to be used, depending on the make of camera and type of file, which will need to be downloaded. JPEG files, on the other hand, are universally easy to open and also write quicker to the

memory card than RAW files which is why sports photographers prefer them . Like all things in photography, you have to weigh up the compromises to find the option that works best for you.

ISO RATING

The ISO rating provides a standard measure of a sensor's sensitivity to light. The higher the ISO number the more sensitive to light and the lower the ISO number the less sensitive to light. Low ISO ratings generally fall between 80-200 and this is when the cameras create the finest images and the settings that as a tree photographer I strive to use as much as possible. Medium settings fall between 200-640, fast settings 640-1200 and very fast settings even higher.

The camera sensors produce a small electric current when exposed to light which is converted via processor into an image. As you change the ISO setting the effective sensitivity to light is achieved by boosting or increasing the strength of the signal. This has an unwanted side effect called 'signal

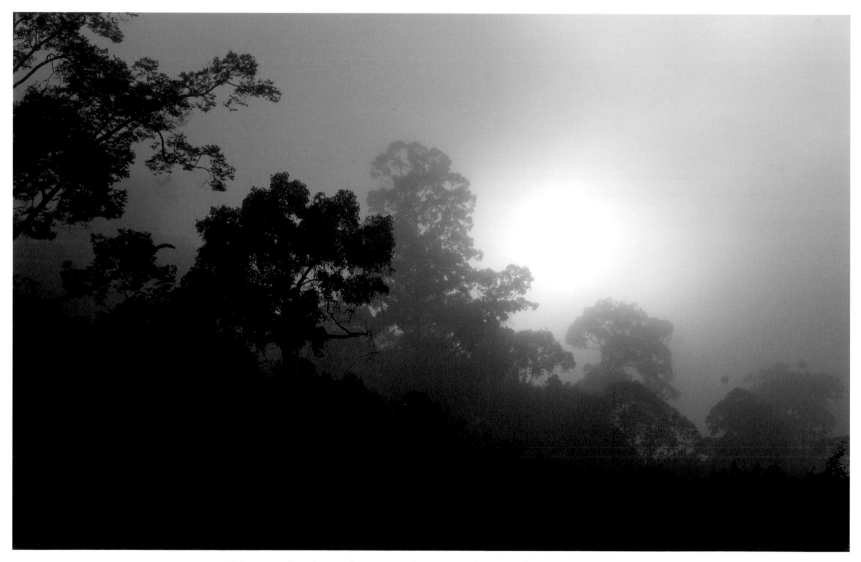

ISO 100 used on this rainforest scene from Borneo because of still conditions *Canon EOS 5D, 135mm F2L, 1/60th sec F8 (tripod)*

noise'. So the higher the ISO setting the more noticeable the effects of 'noise' will be on the final image. Fortunately, in many modern cameras there is a 'noise reduction' facility in the camera. Also, there is noise reduction software that can be used in post processing which can reduce the effects but it is still best to avoid it if possible.

For our purposes trying to use the lowest ISO setting will enable us to get the finest images possible.

I went out on a windy dark day in Cumbria to take the image below. The conditions meant that a higher ISO sensitivity was required to have the shutter speed that would freeze the movement.

ISO 500 and fill flash used in order to help freeze movement on stormy day *Canon EOS 1Ds, 16-35mm F2.8L, 1/250th sec, F8 (fill flash)*

HOW TO PHOTOGRAPH TREES

In this part I will introduce the many ways in which trees can be photographed. This ranges from the classic image of a single tree standing in isolation in a landscape, which is much loved by publishers but not always possible, to the wonderful array of details such as leaves, flowers, fruit, bark and more.

By the time you reach this part you will already have an understanding of how to use light, composition, foreground and other ways to improve your photographs. You will also be aware of how to take control of certain settings to allow you to get the images you desire.

This section is designed to provide examples of my experiences of photographing in a wide range of conditions. They highlight why certain settings have been used and certain decisions have been made, based on the understanding gained from the first two sections of the book.

With each of the photographs in this section I will try to explain the thoughts and decision-making process that went on behind them. For example, I will explain why I used particular settings relating to the quality of the final image, why I chose a particular lens setting, why I thought a particular quality or angle of light would work well and so on. I will also bring in some practical examples where I have had to think on my feet and problem-solve in order to get the final image.

Finally, although I have used examples of my work from all over the world, don't think that it is not possible to get fantastic photographs of local trees. Some of my favourite tree photographs are taken in towns and cities. You will often find me at the Royal Botanic Gardens, Kew in London taking photographs of the spectacular autumn colours or inside the Palm House photographing details of rainforest plants. City parks across the world often have fantastic, exotic trees such as ginkgos and acers, which are among my favourite trees to photograph. Interestingly, of all the tree photographs from all the countries I have worked in, the image chosen for the cover of the book is an oak tree taken just six

WHOLE TREE

Usually the most obvious approach to photographing a tree is to try and get the whole subject in the frame. Publishers love this sort of image, but in many cases it can be quite difficult to achieve. The coastal redwoods of California, for example, grow in dense forests and the tallest among them is an astonishing 115 m, so it's virtually impossible to get an entire tree isolated in a photograph. Fortunately, there are many situations where trees stand prominent and proud in both wild and not so wild situations, such as parks and gardens

Right is one of the most curious trees I have ever photographed. *Welwitschia* is a stunted woody plant that is a conifer related to pine and fir tree, but has developed along an evolutionary line all of its own. It grows in the desert of Namibia, close to the coast, and although it rarely reaches more than 2 m tall, it is thought to be able to live for over 1,000 years.

The decisions that went into this image started with finding out where it grew and how to get there. I carried out research and found that the oldest examples were in a particular part of the desert in Namibia and that it was possible to drive to see them in half a day from the airport of the capital city. Then I thought about equipment and quality of the image. Because it was to be an 'environmental' image, showing the strange plant in its surroundings, I knew I would be using a wide angle lens. I then made sure I had a tripod so that I could use a small aperture to get everything in focus without having to worry about camera shake when using a slow shutter speed. I also made sure I had fully charged batteries.

Once in position I then made a series of decisions that demonstrates many of the techniques discussed in Part One of the book. The composition has the horizon on one of the imaginary third dividing lines and the tree is offset from the centre. The leaves on the bottom right create the foreground, which helps the viewer to get an understanding of depth and perspective. Finally, the soft, low-angled light of dawn creates gentle highlights and shadows to give the visual clues about the three-dimensional nature of this extraordinary tree, and the pink sky is a great background.

The bizarre-looking *Welwitschia*, coastal desert of Namibia
Corfield medium-format camera, ¼ sec, F22

Expert tip

Country and city parks are great places to find trees that are standing on their own. Also, many parks feature ornamental trees from all over the world that can make excellent subjects, especially in blossom or with autumn foliage. If you stand well back and use a telephoto lens it is often possible to hide distracting background and people in the park and produce an image that looks like it may have been take in the wild.

The African mahogany tree, right, was growing deep in the Congo forest. It was just one of several hundred photographs I took whilst I was working for two weeks in the rainforest. Therefore many of the decisions I made were to do with having the right equipment such a full range of lenses, backup body, spare batteries, especially as I was not always able to find a place to charge them, sometimes for days on end. I also had to think how to protect my cameras from possible tropical storms. As well as having a waterproof camera bag I tend to put each lens and flash into individual plastic bags as well, because when the bag is opened kit can become damp.

For this image I used a super wide-angle lens setting on my trusty super-wide to wide angle zoom, which, because of the distortion of perspective, makes the tree appear even taller than it is. I solved the problem of looking directly up into the tropical sun by positioning myself so the sun was part shaded by the canopy of a neighbouring tree. The composition isn't conventional but I think it works well. I also took several exposures to make sure I had a correctly exposed one to take away. Fortunately, there was plenty of light and I used a small aperture to make sure that everything appeared in sharp focus, but I was still able to select a shutter speed fast enough to enable me to hand hold the camera.

Overleaf is one of my favourite photographs of a British tree. It was the country's largest wild cherry, with a trunk measuring a massive 5.7 m in girth. Unfortunately, it was blown down in a storm and this remains one of the finest photos taken before its demise.

The decision-making process for taking this image started months before-hand. I knew that this was a tree that I needed to take a photograph of and I knew that there would be just a couple of days in the spring when it would be covered in perfect blossom. From asking the park warden I found out that the best time would be late April/early May. I then planned to visit it over a weekend that promised weather conditions of sunshine and showers.

On the actual day I chose to use a wide-angle lens and by keeping the camera perpendicular (upright) to the ground so that there is virtually no distortion. (Distortion only happens if you tilt the camera up or down with a wide angle lens.). As most of the tree was set at a distance from the camera and effectively near infinity in terms of focus the aperture setting became less of an issue. However, I set an aperture which I knew would produce the sharpest image possible (one of the middle aperture settings). I then enhanced my chances of producing a super high quality image by using a tripod and a remote shutter release to eliminate any camera shake.

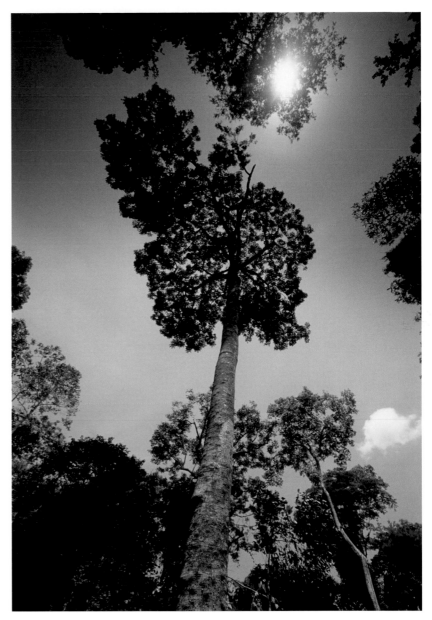

An African mahogany tree, central Congo
Canon EOS 1Ds, 16–35 mm F2.8L (at 18 mm), 1/30th sec, F11

Expert tip

It is worth waiting for a shower to clear and the sun to come out again, because for a short while afterwards the air is usually clear of haze and any pollution, giving bright blue skies or beautifully defined clouds..

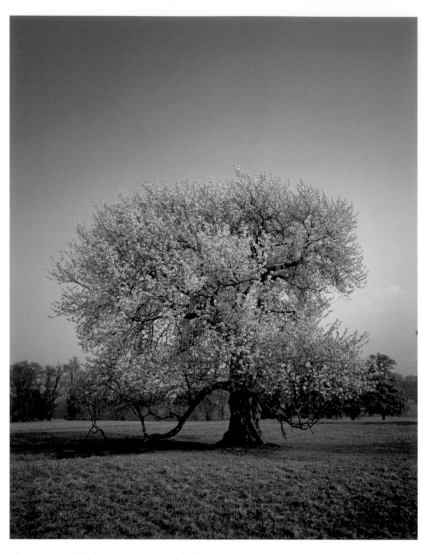

Coconut tree on Mafia Island, Tanzania
Canon EOS 1v, 28–70 mm (at 28 mm) F2.8L, 1/90th sec, F8

The largest wild cherry in the UK in full blossom, Yorkshire, England
Canon EOS 1v, 16–35mm F2.8L, 1/15th sec, F13

Despite the benign-looking conditions, I had to wait several hours to get the photograph I was looking for. I endured thunder and lightning and a series of stinging hail showers before the sky cleared briefly and I was able to get this iconic image of white blossom on the largest wild cherry in Britain set against a perfect blue sky. In the end I was cold and wet and tired but the image was worth it.

Palms, such as this coconut tree, are good subjects to photograph individually. This image employs many of the techniques highlighted in Part

One. It is an image that could be taken equally well on a compact or hybrid camera because the good photographic conditions means that all of the cameras could use optimum settings for quality because of the plentiful light. I chose a wide angle lens for another 'tree in setting' image. The composition is comfortable on the eye because the main tree is lined up directly on one of the imaginary third dividing lines. I also like the repetition in the background of the main tree. The light is near perfect, angled at about 45 degrees (look at the shadow of the trunk at the bottom right). Despite it being taken with quite a wide-angle lens, keeping the camera perpendicular has eradicated potential distortion. There is even a goat which gives the tree scale.

FILLING THE FRAME

It is often quite difficult to take a photograph of an entire tree, sometimes because it's set deep in a forest and other times because the background, such as a boring, overcast sky, detracts from the image. 'Filling the frame' type photographs are one of my favourite ways and most successful ways of photographing trees and many of these types of images have been used full page or double page in magazines and books.

Right is one of my favourite trees in London. It measures more than 8 m around the trunk and stands quietly in a postage-stamp sized wood right in the heart of the capital.

The decision making process for this image started by knowing that I would be able to drive my car close to the tree. This meant I could carry my whole camera equipment without any problem. I then spent the previous days trying to predict which day in May would provide the best opportunity for light and skies. May is my favourite time for photographing trees in the UK because the leaves are fresh and translucent and generally a vivid green. In addition, the days are starting to get longer, but the angle of the sun remains low in the sky for all except a couple of hours in the middle of the day. Coupled to this a day of 'sunshine and showers' enables one to have the opportunity to photograph in a variety of lighting conditions and with a variety of background skies.

Here, I used a wide angle to get a lot of this giant tree in and a person to give scale. Notice how the low-angled spring light creates the highlights and shadows to help the viewer understand the shape of the trunk. The green foliage at the bottom creates good foreground, while blue sky occupies the top third, capping off a visually satisfying image. The photograph was taken for a campaign, with television coverage very much in mind (horizontal format, scale, beautiful light), and in the end it featured on the news no less than six times in one day and was seen by millions of people.

The largest London plane tree, London, England
Canon EOS 5D, 16–35mm F2.8L, 1/30th sec at F11

Expert tip

Using a telephoto lens not only allows you to isolate a tree and make it fill the frame, it also helps to hide a distracting background, or disguise the fact that the tree might have been photographed in a busy park.

This photograph was taken in the Solomon Islands for a book about economic plants, to show coconuts growing in a tropical location. It was shot in a very remote location so my first decisions had been mainly how to get to the northern islands in the Solomons, with not only what equipment I would need but also what I would be able physically to carry and even what weight restrictions were in operation on some of the small propeller planes I would be using. As with all remote, tropical locations I made sure I had a good range of equipment, spare batteries and enough film and memory cards to be able to shoot freely.

As usual I was on a tight time schedule and I knew for much of the day in the tropics the high angle and brightness of sunlight would make getting good images of trees difficult. Here, I worked out a way of turning this problem to my benefit, by choosing a tree close to the water's edge on the beach and taking advantage of the sun reflecting up from the sea and sand beneath it, which bathed the coconut tree in unusually warm, even light.

Filling the frame edge to edge helps to concentrate the eye on the nuts and palm fronds and means that there are no extremes of light to cope with. The composition positions the main cluster of nuts firmly on the top third imaginary dividing line. Using a telephoto lens has not only allowed me to use a tight cropping for the composition but created an almost flat 2D perspective.

The photograph, opposite right, in southern England was taken on an overcast day after a night of rain. Again, as it was a place I knew I could drive to, I was able take my entire kit; batteries could be charged during the day if necessary. I then headed out with a full-ish camera bag and tripod. I chose this particular day because I knew that overnight rain was scheduled to ease and the conditions were set to brighten slowly during the day.

The composition is the classic 'rule of thirds' and the colours are rich because of the recent rain, (the foliage gets rinsed of dust and dirt after a shower) and the soft, diffused light. A telephoto lens helps to isolate the tree and using a longer lens helps compress the perspective, giving the impression that the bluebells and tree are closer together than they actually are.

I took the photograph, opposite left, in the middle of the Amazon and I think it really captures the atmosphere of the deep rainforest. The decisions that went on behind this image actually began months in advance. As I was looking for particular tree species that lived to over a thousand years old in the Amazon, I needed expert help from local botanists to help me locate

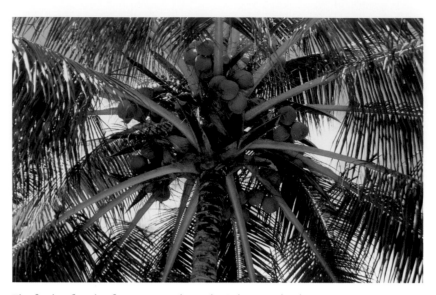

The feather fronds of a coconut palm in the Solomon Islands
Canon EOS 1n, 28–70 mm F2.8L, 1/125th sec, F5.6

examples. I emailed people over many weeks and finally managed to find a scientist who could help me. I then planned to visit when I had enough work in Brazil to justify a trip. I was not able to choose which day and what weather conditions would be good because I was having to work on someone else's schedules. Also even in the 'dry season' it rains heavily in the Amazon most days.

My decisions on the day were governed by wanting to show particular species in their rainforest situations. For me, this was one of the most successful images and again is a 'filling the frame' type shot. I chose to use a wide angle lens and by tilting it upwards I was able to make the trees seem even taller, even more magnificent, because of the effect on the perspective. Then I chose a view point which had a good foreground of leaves around the edge of the image, to create a feeling of depth. The most important decision to make for this image was to select the aperture as I wanted as much in focus as possible. I chose a very small aperture and focused on the hyper focal point – which is generally about one third of the way into the scene. Everything was set on a tripod to make sure I didn't lose any images to camera shake. It would have been criminal to have lost any photographs to simple errors such as this considering how much planning had gone in to the trip, also it was likely to be my once only opportunity of a life time. I specifically

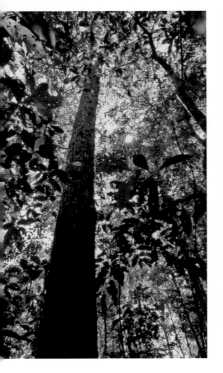

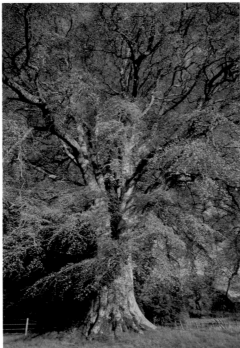

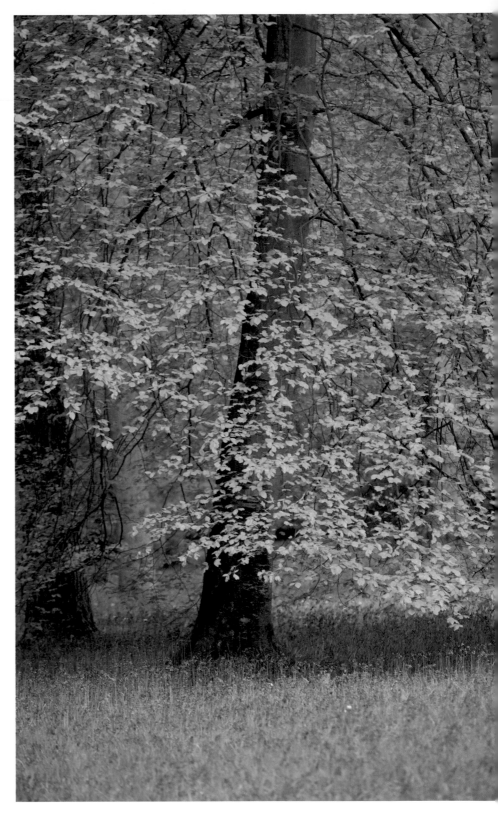

The interior of Amazon
rainforest with giant trees,
near Manaus, Brazil
*Corfield medium-format
camera, 21 mm (equivalent),
1/8th sec, F22*

The largest beech tree in Scotland
Canon EOS 1v, 28–70 mm, 1/30th sec, F11

A classic British scene of mature oak tree standing
in among bluebells in Spring, Dorset, England
Canon EOS 1Ds, 135 mm F2L, 1/200th sec, F4

wanted the upper leaves to be backlit, but had to wait quite a while to get the right conditions. Fortunately, the clouds were moving swiftly across the sky prior to an afternoon storm so eventually the perfect conditions arrived. I chose the brief instant when the sun was diffused through a small white cloud. In the end there were probably only a couple of minutes in a whole afternoon that were perfect.

Above centre is a perfect image of a massive Scottish beech tree in May. This was one of a number of Scottish trees I chose to photograph in spring for a book I was working on. I chose this month because it was when the leaves were bright green and the weather conditions were alternating between heavy showers and bright sunshine. It looks spectacular set against a patch of blue sky in the fabulous afternoon light.

TREE TRUNKS

A European plane tree in a small town in Provence, France
Canon EOS 5D, 135 mm F2, 1/250th sec, F4

Tree trunks are the tree photographer's friend. There is almost no situation where it is not possible to photograph the trunk (or bark) of a tree. It can be blowing a gale or as dark as night but it is still possible to get an interesting image.

The photograph left is a section of the trunk of a plane tree in southern France. I was on holiday but I had spotted some interesting trees and, unusually for me, I headed out in the middle of the day. This made photographing whole trees difficult but I found that the brilliant Mediterranean sunlight was being reflected off the buildings on one side of the streets, onto those in shade. This created soft, attractive lighting which was perfect for photographing the bark detail of the plane tree. I used the classic composition of having the subject lined up on one of the imaginary third dividing lines and positioned myself so the pastel colours of the background complement the patchy coloration of the bark.

Right is a tree that has one of broadest trunks in the world. Called 'El Tule', it stands close to the city of Oaxaca in central Mexico and its trunk measures 36 m in circumference. I was already working in Mexico and took a side trip to visit this amazing tree.

As for planning Oaxaca has a wonderful spring-like weather almost all year so I was lucky in that I didn't have to plan for to visit in a particular season. Also its open aspect means that it is easy to get access to and only a short bus ride from Oaxaca City. Needless to say, I was obliged to use a wide-angle lens to get the whole trunk in. I also waited for clouds to cover the sun so that the shadows from the canopy became less of a problem. To me, this tree, which is sacred to the local Zapotec people, is like a living cathedral with flying buttresses similar to those of Notre Dame Cathedral in Paris.

The tree overleaf, despite appearances, is still very much alive and is in a grove of bristlecone pine trees that are mostly more than 4,000 years old. The planning behind this

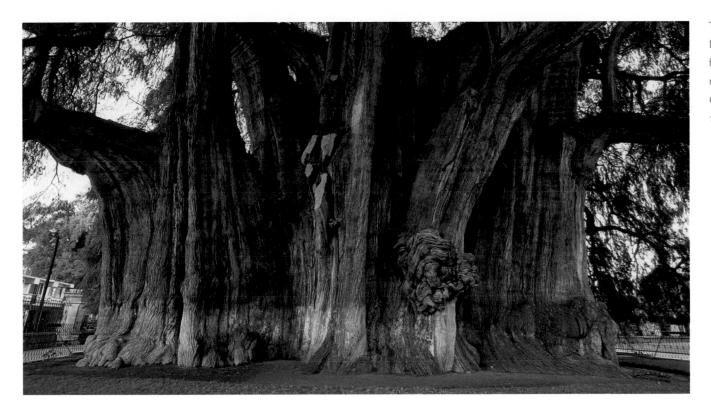

The trunk of 'El Tule' – a giant Montezuma cypress that has fabulous burrs and buttress roots, Oaxaca, Mexico
Canon EOS 1n, 20mm F2.8, 1/45th sec, F11

photograph was quite involved. It was taken for the book *Ancient Trees – trees that live for a thousand years* and was a key image for the book. Back in the UK I had researched where the grove containing the oldest verifiable bristle cone pine trees were to be found. Then I found that, because of the altitude they live at, they are closed off to the public for around half of the year due to ice, snow and intense cold. My idea was combine the photography with the giant redwoods that are also in California, but I wasn't expecting them to be a good day's drive apart.

On the actual day I arrived at the nearest car park around four in the morning and started walking up the mountain path, since there was sufficient light that I could see by. It took a few hours to hike up into the White Mountains to get the opportunity to photograph one of the oldest living trees on the planet. The fabulous shape of the trunk is the result of it being sculpted by the sand and ice carried by the ferocious winds that occur at nearly 3,000 m above sea level, where the oldest trees live. I chose a tree in shade, so that all the subtle colours and striations would be clearly visible.

Interestingly, the forward planning required to get the shot was the most important part of this photograph. Once I had actually reached the grove of ancients I used my trusty 28-70mm F2.8 zoom at the 70 mm lens setting which gives a near perfect human-eye perspective for a good record shot and I used a tripod and an aperture of F11 to create the sharpest possible image of the tree. The inclusion of foreground at the bottom of the photograph helps to create the depth that the brain is looking for. I chose a tree still in the shadow of the mountain, where the reflected light from a pale rock outcrop gave just enough soft angled light to create subtle highlights and shadows for the brain to get an idea of the tree dimensional nature of the trunk. Finally, I thought that it would work well as an abstract; a sort of glorious organic sculpture that has been created over thousands of years in a hostile environment.,

Expert tip

Photographing tree trunks is a real leveller between those using expensive DSLRs and those using compact cameras. The best tip in both cases is to invest in or borrow a tripod, so you can get shake-free images even in poor light.

One of the largest yew trees in Wales at Bettws Newydd
Canon EOS 1v, 28–70 mm F2.8L, 1/8th sec, F16

The weathered trunk of an ancient bristlecone pine, California, USA
Canon EOS 1n, 28–70 mm (at 70mm), 1/60th sec, F11

This grotesquely contorted trunk (above right) belongs to a yew tree in a churchyard in South Wales that is believed to be more than 2,000 years old. My planning for this tree included arriving at dawn on a summer's morning. I was able to utilise the low morning sun angling across the tree to help create some nice highlighted areas on the trunk, bringing out the rough texture of the bark and giving visual clues as to the three-dimensional nature of this monstrous tree. I decided that it would work best almost an abstract – to give it the appearance of the sort of tree that could have been in *The Lord of the Rings*, because it is so ancient and so full of character and history. Typically, for this sort of photograph I was using a wide angle lens on a tripod and setting everything to get the sharpest, shake free image possible. Within an hour of arriving the light had become harsh and unpleasant which proved the early start had been a good idea.

Note that a new trunk is developing in the hollow that well help it to survive for possibly hundreds of years into the future.

LEAVES

Leaves are a continual fascination to me. They provide so many opportunities to get great images wherever you are in the world. They are accessible to everyone – found in parks, gardens, tropical green houses - and photographing them can work as much to the advantage of those of you using compact cameras and hybrid cameras as a photographer with a big DSLR.

I recently had the great fortune to travel to the eastern seaboard of the USA to see the autumn colour. The display was stunning – I had never before seen such great swathes of brilliant hues. It provided great opportunities for photographing sweeping vistas and, of course, leaf details.

The planning for the trip started several months before I actually arrived and it is one of those circumstances where the better the forward planning the better the photographic opportunities will be. I must admit to agonising over which part of the Eastern seaboard of the USA to visit. However, once I had made up my mind I knew that I would be able to take great photographs, whatever type of camera I was using.

I took the image to the right with a super wide-angle lens and, because I'm tilting the camera down a little, there is a bit of distortion in the perspective. Nevertheless, the colours are wonderful, thanks to the overcast conditions (it was actually drizzling as I took the photograph), and the foreground is strong, giving great depth to the image.

I like the image overleaf of fallen ginkgo leaves for a number of reasons, not least because I took it in the most awful weather (cold, rainy, overcast) and it's always pleasing to show that perfectly good photographs are possible in what are considered poor conditions. In fact, under cloudy skies the leaves were gently illuminated to perfection, like the very best studio lighting set-up. And without bright sunshine, there were no problems with shadows when I set the tripod directly over the ginkgo leaves. As an added bonus, the rain had kept the fallen leaves

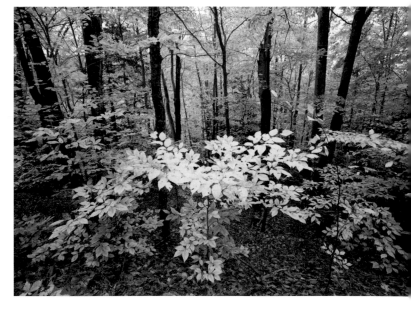

Woodland in New England in full fall colours, USA
Canon EOS 5D, 16–35 mm F2.8L (at 20mm), 1/20th sec, F10

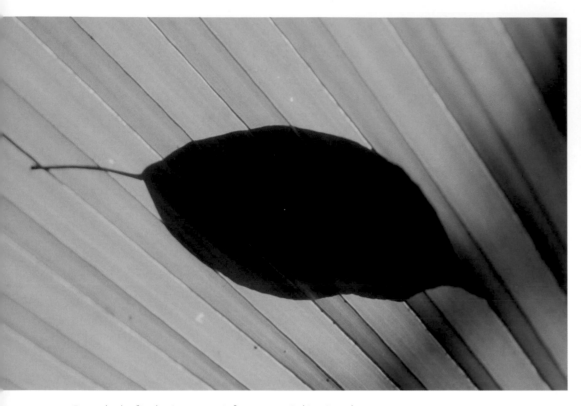

Ginkgo leaves on the ground, Kew Gardens, London, England
Canon EOS 5D, 100 mm macro, 1/8th sec, F5.6 (on tripod)

Fan palm leaf in the Amazon rainforest, near Belém, Brazil
Canon EOS 1n, 100 mm macro, 1/125th sec, F4

Expert tip

It's useful to have a macro lens for photographing leaves with a DSLR, but most compact cameras can take great close-ups without any extra equipment.

fresh, and the water droplets actually enhance the photograph. I used a tripod and specialist macro lens, so ended up faffing around for quite a few minutes. This is a situation where a compact camera is often faster and much more convenient than more professional and complex equipment.

The composition is classic 'rule of thirds' and I was able to use almost any aperture I wanted, because all of the photograph was pretty much in the same focal plane. The choice of background was important. I could have had some of the grass showing through, or a single leaf on a background of only grass, but I thought the repetition of the leaf shape worked best. It took me a few minutes to find the best location even though it was essentially just a pile of leaves on the floor.

When I photograph leaves, I can often be seen crouching down, checking whether backlighting will enhance the result. In one case, above right, I was delighted to find a leaf resting on the fan palm, so I positioned myself so that the sun was shining brightly through the palm frond. Note how the

background is yellow and green and divided approximately into one third green and two thirds yellow. The silhouette of the leaf which breaks up the pattern of the palm frond works really well. Although I photographed this in the heart of the Amazon a similar image could be taken in one of the tropical houses at Kew Gardens or even at home with a table lamp. Taking advantage of backlighting of leaves is a good way to get some quite stunning images.

Photographic opportunities can occur anywhere, as the image overleaf demonstrates. I was casually sipping a coffee in a street café in a small town in southern France when I noticed a plane tree leaf floating in the town square fountain. I love the hard, angled light, which casts a near perfect shadow on the bottom of the pool, and also the pattern of ripples. Note the classic rule of thirds composition. This image is less planned but I am always ready to turn situations to my advantage. It is the sort of image that is perfect for the compact camera user. My main consideration was shutter speed, because the pool was fed by a fountain and the leaf was moving around in

A close-up a liquidambar leaf in a London Park, England. I took this image during one of my photographic courses by way of a demonstration. The idea was to show how to isolate a colourful leaf using a telephoto lens, making the most of the interesting lighting. I like the strong red colour and the pale, out-of-focus background, achieved by using a large aperture (see Part Two). *Canon EOS 7D, 135 mm F2 (equivalent to 180 mm when used on APS-C camera), 1/400th sec, F2.8*

the water. Happily, it was a very bright day and so I could use a fast shutter speed without having to use a high ISO setting.

Autumn and spring are my favourite times to go out and look for leaves to photograph, and it's not necessary to travel very far to find great opportunities. The maple at the Royal Botanic Gardens, Kew, on p. 103 had a fabulous display of lemon-yellow autumn leaves. On this occasion I had been watching the weather forecasts for a couple of days as I knew there should be some great autumn colours and I was just waiting for the right weather conditions. I planned to go to Kew because it was set to be a day of sunshine and heavy showers. This often produces sharp sunlight (the skies are washed clean of haze and pollution by the rain) and brooding black skies, which are great for backgrounds. I used the closer leaves as good foreground, giving depth to the image and leading the eye in. Kew Gardens has literally hundreds of different types of trees from all over the world that can look fantastic in Autumn.

My main decisions with this photograph was to represent the strong lemon yellow leaves as best I could. Happily, it was a reasonably windless day so using a tripod I set the camera on the finest quality setting (ISO 100), also used a small aperture and focused on the hyper focal point to ensure everything was in focus. Note how the black sky makes the brightly lit leaves stand out. Had it been a white/grey sky the photograph would not have worked so well.

Plane tree leaf in a water fountain in a small town in Province, France
Canon EOS 5D, 16–35 mm F2.8L (at 35 mm), 1/125th sec, F5.6

Fan palm leaves in the rainforest, Australia
Canon EOS 1n, 20 mm F2.8, 1/30th sec, F16

One of the beautiful features of the Australian tropical rainforest is the fan palm, which provide a delightful understorey (opposite). Here I've used a super wide-angle lens to enhance the composition, making the fronds in the foreground prominent, to lead the eye into the scene. I waited for a while until a small fluffy cloud briefly covered the sun to get the softer quality of light I was looking for. Again this is just the sort of image that is possible to take with any type of camera and also is easy to replicate in a botanic garden's tropical palm house or even a garden centre. Note the tightly cropped composition. This is just what would need to be done in an urban palm house because it hides the background and can imply that the image has been taken somewhere exotic.

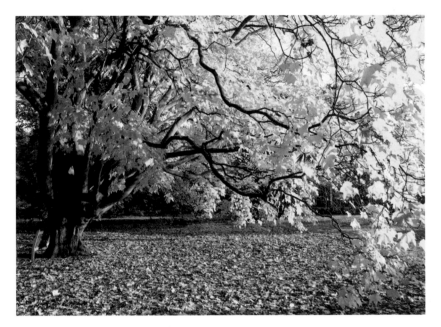

Spectacular yellow foliage of Cappadocian maple, Kew Gardens, London, England
Canon EOS 5D, 16–35 mm F2.8L (at 20 mm), 1/30th sec, F13

Banana leaf taken in the Palm House at Kew Gardens, London, England
Canon 40D, 100mm F2.8, 1/4 sec, F11

BARK

This is another area of photography where the compact camera user can achieve equally striking results as someone using a DSLR. The opportunities to photograph great bark are everywhere – in parks, in gardens and in the wild. Not only that, but trees grace the world with so many exquisite manifestations of bark that your options are nearly endless. Sometimes it is smooth and colourful, other times the ravages of time have rendered the bark of an ancient tree deeply fissured and full of texture and character. With bark, as with tree trunks, there are almost no conditions where it is not possible to take good photographs, especially if you have a tripod to hand.

All over the world there are trees that are sacred to people. In this case I found a 'wishing tree' studded with tarnished copper coins that had been hammered into the bark over hundreds of years. The blue/green of the copper coins provided an unusual photograph of what would otherwise have been quite plain bark. This is yet another example of where planning was one of the most important parts of getting this image. I had heard about the tree and I knew that it was on a remote hillside on the Scottish coast, but it was still very difficult to locate. Once there I used my standard zoom and set about taking tight detail photographs of the tarnished blue-green copper coins and the grey bark. I used a tripod so I could keep the quality of the final image high and I experimented with a series of different F stops until had an image I was happy with. In the end the bright afternoon light didn't seem to work so well for this photograph (a combination of quite subtle colours), so I waited until late in the afternoon, when the trunk was in shade, before taking the final image.

In the photograph opposite far right, I created an abstract image of harvested cork oak. I was in southern Spain at the time, documenting the work of the traditional cork oak harvesters, who use the same sustainable techniques that have been practised for hundreds, if

Wishing tree studded with coins in Argyle, Scotland
Canon EOS1V, 100 mm F2.8 macro, 1/15th sec, F11

Thorns on the trunk of a young kapok tree, Veracruz, Mexico
Canon EOS1n, 28–70 mm F2.8L, 1/125th sec, F5.6

Harvested cork, Andalucía, Spain
Canon EOS 1n, 28–70 mm F2.8L, 1/30th sec, F11 (on tripod)

not thousands, of years. I was drawn to this image by the abstract pattern made by the pile of bark pieces. Even though it was August and the temperature was over 30 degrees centigrade, I was able to find a side to the pile of bark that was in shade and which had warm light bouncing up from the ground on to it. With bark photography I love to look for the abstract patterns and the textures.

Many trees, such as the kapok tree above, have protective thorns and spines set in their bark. I loved these rusty-coloured thorns set on the almost apple green trunk. Note how the angled light gives a good idea of the shape and texture of the bark. Kapok trees, which can grow to nearly 60 m tall, are

sacred to the Mayans and a number of other indigenous peoples of Central America, as well as producing a downy seed fluff that is commercially important. This is another image that could have successfully been taken on any type of camera. The advantage of the compact camera is that it can be so much quicker than a DSLR. Also because you are not carrying so much weight it is easier to carry to more extreme locations and easier to have it on you all the time.

The photograph overleaf, top right, hangs in pride of place on my wall at home. It began as a challenge from someone who said, firstly, that this particular tree had been photographed a lot and there was no room for any new

Close up of the bark of the Belton yew in Northumberland, England
Canon EOS1Ds, 28–70mm F2.8L, 1/8th sec, F8

Cherry bark
Canon EOS 1Ds, 135mm F2L, 1/250th sec at F4

Birch bark, Worcestershire, England
Canon EOS 1Ds, 28–70 mm F2.8L, 1/30th sec, F11 (on tripod)

angles and, secondly, that it was a filthy day and taking a good photograph would be near impossible. Using a tripod and facing away from the driving rain I selected a particularly colourful area of bark that was also beautifully textured. It has become one of my best known photographs. It demonstrates that with simple equipment and by taking advantage of the conditions it is possible to get a great image with almost any type of camera. However, the use of a tripod in this instance has meant that I have been able to use the finest ISO setting and the sharpest aperture (F11) to get a wobble free image.

Above, the subtle shades within a bark, such as those of this silver birch, are often more visible on the shaded side of a trunk, while a different effect can be achieved with side lighting, such as on this gorgeous cherry tree bark, above left.

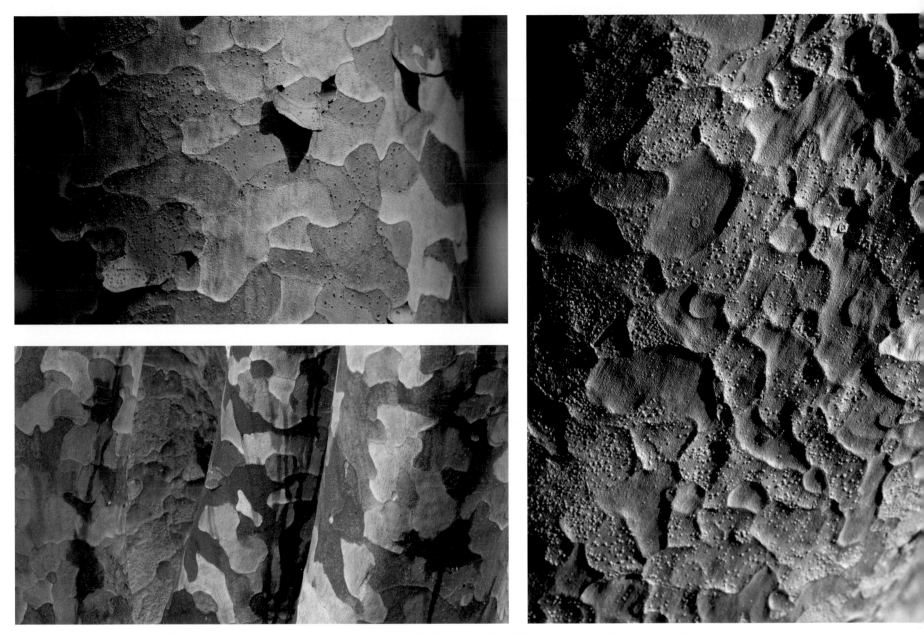

Different views of Kew's lace-bark pine *Canon EOS 5D, 135mm F2L above left 1/250th, F4 (tripod), left 1/8th F16, and right 1/60th, F11 (tripod)*

Look at the three photographs above. All are taken of the same bark on the same tree, just a couple of days apart, using different qualities and angles of light, and one after heavy rain. The tree is the largest lace-bark pine and stands in the Royal Botanic Gardens, Kew. This trio of images is a good example of the sort of range of effects and interesting results that can be achieved with a little thought using trees in a garden or park.

Expert tip

I like photographing bark on rainy days, because sometimes the colours look much more spectacular when the tree is wet.

FRUIT, SEEDS & FLOWERS

Trees have a wonderful variety of ways of reproducing. Each species has its own unique flower, seed, nut or fruit, providing almost limitless opportunities for the photographer. It is another area of tree photography where the advantages of the compact camera and the way they can easily document details make them almost a match for the more complex camera systems.

The quince fruit lying in the frosted grass on p. 110 provided a simple yet striking opportunity for a photograph. I chose low, early morning sun to create the soft highlights and shadows, which give form to the fruit. Also, note that there is a lovely dynamic tension in the composition between the fruit, each falling on a third/third intersect in accordance with the rule of thirds (see Part One, Composition). The yellow also leaps out from the green background. All in all, a beautiful photograph that anyone with any type of equipment should be able to achieve.

The fruits and leaves of an olive tree make a rather pleasing image. I chose to photograph them on a collecting sheet that was in the shade, because I thought the subtle, diffuse light would show the varying shades and shapes better. The fruit and leaves make a delightful abstract pattern which is the sort of ideal image that could be used for the end papers of a book on olives or as a double page spread in a Sunday magazine. Again, I knew I would be able to get a pretty good image regardless of the equipment I used because I did not have to worry about depth of field (focus) due to the flat nature of the image I was able to use a largish aperture, so was able to take the image without the need to get the tripod out.

Tree flowers, such as the beautiful willow catkins, opposite, can make very pleasing subjects. Here I used a telephoto lens to select just a small part of the tree and a large aperture to make only one flower in focus. I found an angle where the sun is shining from behind the flower, which highlights its feathery, delicate nature.

Harvested olives in net on the floor of grove on Crete, Greece
Canon EOS 1Ds, 28–70 mm F2.8L, 1/60th sec, F5.6

Expert tip

If you're having trouble photographing some blossom, berries, or seeds growing in your garden, you could consider clipping off a small sprig so you can set up the photograph indoors or in an area where the light is perfect or the wind less of a problem.

Close up of willow catkins, Dorset, England
Canon EOS 1Ds, 135 F2L, 150th sec, F2.8

Holly in churchyard, Somerset, England
Canon EOS 1DN, 28–70 mm F2.8L, 1/125th sec at F8

Berries, such as those found on trees like holly, can add a splash of brilliant colour to a photo that may have been predominantly green in another season. The hard, low light and the glorious blue sky help to make the deep green of the holly leaves and the red of the berries rich and punchy. Holly trees are one of the more difficult trees to photograph because of their dark green leaves so take advantage of good light or conditions like an air frost to help get a great image.

A few years ago I was working on a story about a group of indigenous people in the Andes, in Chile, who not only collect monkey puzzle seeds as a major part of their winter diet but also even take their name from the tree. They call themselves 'Pehuenche', with 'pehuen' meaning monkey puzzle and 'che' meaning people. As part of the photo-documentary I photographed the forest, individual trees, people collecting the seeds in the forest, but I also needed an image showing the proteinaceous seeds in the hand of

Fallen quince fruit in the grass on a frosty morning, Dorset, England
Canon EOS 1v, 100 mm F2.8 macro, 1/15th sec, F13 (tripod)

Monkey puzzle seeds in the hand, South-central Chile
Canon EOS 1n, 50 mm F1.4, 1/60th sec, F8

Elderflowers, Dorset, England
Canon EOS 5D, 16-35mm F2.8L, 1/30th Sec, F16

someone, to help tell the story. To create the image I needed of monkey puzzle seeds being collected by the Pehuenche permission was required to photograph seeds in a woman's hands. I asked her to sit so that the sun lit them from a low angle, also to rest her hands on her black skirt to create a neutral background. The hands add interest and give scale to the seeds. This image is as much a product of thinking what I needed and how to manipulate the situation to get a good image as it is about technique. Sometimes just moving a person into a better position relative to the sun can really make an image a whole lot better. The same is true of fallen fruit. Sometimes I will move something like a fallen nut into a place where the light or background is better.

Palms make beautiful photographic subjects. To achieve the date palm shot in Tunisia, opposite, my thought process worked as follows. I chose to use a short telephoto lens to enable me to 'fill the frame' against a background of perfect blue sky. I wandered around the tree until I found an angle where I could use the angled light in such a way as to give the viewer's brain the visual clues (highlights and shadows) it needs to understand the 3D

Date palm on the coast near Sfax, Tunisia
Canon EOS1V, 135 mm, 1/250th sec, F8

A laburnum tree festooned with yellow flowers in summer, Hampshire, England
Canon EOS 1Ds, 28–70 mm F2.8L, 1/125th sec at F8

shape of trunk, fronds and fruit. By choosing a low viewpoint, where I am looking up, I have managed to hide the fact that the tree is in fact in a large industrial port.

Garden trees, such as the laburnum on the right, can provide beautiful subjects when they are in bloom. Here, I have chosen to fill the frame with a cascade of yellow flowers, but I have left sufficient detail at the bottom of the image for the viewer to be able to understand both its location and orientation.

WOODS & FORESTS

I love taking landscape photographs, especially ones that involve vistas of trees, woods and forests. In my work, it is important that I get not only good images of individual trees and their details, such as leaves and bark, but also the setting in which they are to be found. Sometimes this can be as a lone as tree in a desert landscape, such as a baobab tree, but more often it is groups of tens, hundreds even thousands of trees together, often forming great forests that are teeming with life and opportunities.

I was attracted to the scene (right) by the autumn colours, the mist and the low morning light. I chose a high viewpoint and used a 300 mm telephoto lens to help compress the perspective of the scene and make the trees and the hill appear much closer together than they actually are. Notice how I included a thin strip of land and a few trees at the bottom for foreground to help improve the understanding of depth. The autumnal trees lit by the low sun off to the right show up well in the mist.

Of all the forest photographs I have ever taken, the one opposite is one of my favourites. It represents planning, determination, technique and a good dose of competitiveness. When I first pitched the idea to a publisher for the book *Ancient Trees – trees that live for 1,000 years*, I confidently said that I would take better photographs of each of the trees that would feature in it than were available at the time. Confidence is one thing, but the limitations of flying to each location around the world for just a couple of days, on a very restricted budget, adds a certain pressure. So, with the giant redwoods of California I had only three days to get the photos required – an area frequented by many *National Geographic* photographers I should add. Fortunately, my decision to arrive at the first snows of winter and my determination – I spent almost an entire day following the slow plough up to a viewpoint I wanted to get to – worked out. I arrived where I needed a lot later than I had planned and quite a bit after

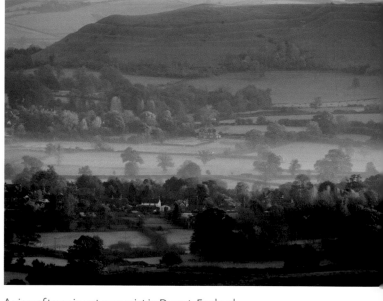

A view of trees in autumn mist in Dorset, England
Canon EOS 1Ds, 300mm F2.8L, 1/60th sec at F8

Expert tip

Head for the woods on misty days, because the light gets spread evenly under the canopy and the mist often blocks out unwanted backgrounds, such as pylons.

Dusk over the largest remaining giant redwood grove, Sequoia National Park, USA *Canon EOS1N, 200 mm F2.8, 13 sec, F4.5*

sunset, but undeterred I quickly selected a lens, set up the tripod and managed a handful of images before darkness completely enveloped the scene. The mist moving through the world's largest remaining grove of ancient giant redwoods and the purple hues of dusk combined to create a wonderful image.

On the photographic side of things I selected a 200mm telephoto lens so I could focus in on two ridges that interested me. This helped compress the perspective and make them appear much closer together than they were in reality. I then used the first ridge as the foreground. My original intention was take this image in afternoon light but I think it worked even better nearly half an hour after sunset with the glorious colours of dusk.

After days of walking in the cloud forest of southern Colombia enveloped in thick cloud, the conditions briefly lifted and I was able to find a high vantage point to get this scene-setting shot to accompany my photographs I had taken of the local people and spectacled bears.

My decision processes are now probably becoming quite familiar to you now. In this instance it was important for me to recognise an opportunity to photograph a forest that can be hidden in clouds for days even weeks at a time. Once the conditions presented themselves I asked the local guide if there was a suitable viewpoint. Local knowledge can be very useful as often there are very few places, especially in rainforests, where it is possible to get a clear view of the extent of the forest. Once I was in place I was able to think about foreground, background, angle of light etc. to make a successful image. Note the inclusion of an interesting background of mountains, which I think enhances the photograph greatly.

A break in the clouds looking over cloud forest high in the Andes of Southern Colombia *Canon EOS 1v, 300 mm F2.8L, 1/200th sec, F8*

The rainforest, overleaf, is almost perfectly illuminated by the sun shining through thin white clouds early in the morning. The lighting is beautifully soft so, although there are some bright patches and shadow areas, they are not so extreme that they become white or black featureless areas on the image, which could detract from the photograph. I included foreground trees on the right hand side of the frame to add depth and positioned the key tree on the imaginary third line running vertically up on the left of the scene. I used a short telephoto lens to help compress the perspective in the scene a little and a small aperture in an effort to get as much of the forest scene in focus as possible.

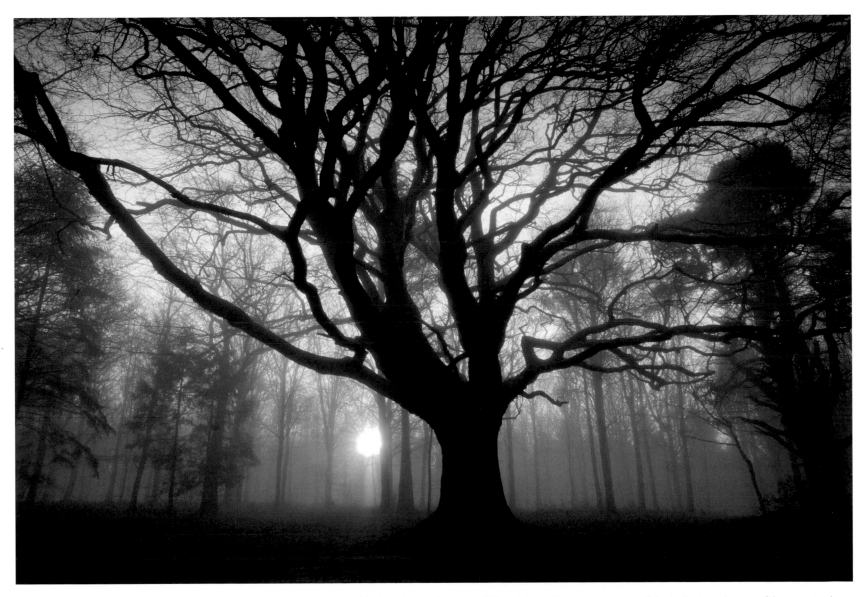

I like this photograph as much for the background as for the silhouette of the beech tree. The sun is diffused through morning mist and the indistinct shapes of the trees in the mist made for a background that was crying out for a subject. *Canon EOS 1Ds, 28–70 mm F2.8L, ¼ sec, F11*

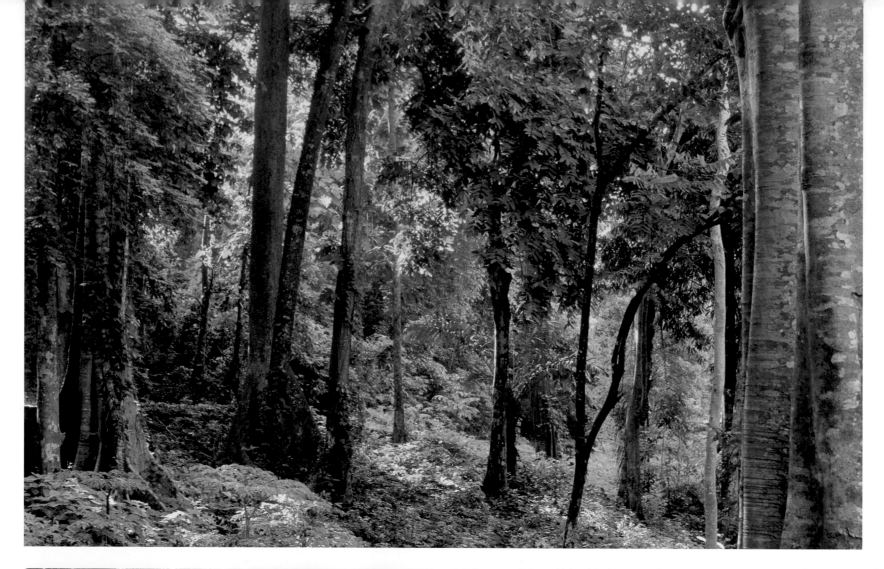

Rainforest on Sulawesi Island, Indonesia *Canon EOS 1v, 135 mm F2L, 1/15th sec, F16*

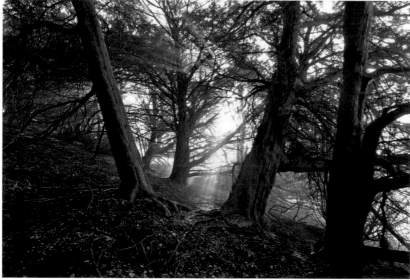

A rare pure yew forest on a misty, winter's morning, Dorset, England.
Corfield medium-format camera, 21 mm (equivalent), 1 sec, F32

This photograph took more than a year to take. I used to live near this unusual yew wood, but most of the photographs I had taken up to this point had been a mess of deep shadows, black/green foliage and burnt-out highlights. What I knew I needed was mist, but the trees were on a hill and quite a way from the river. However, one morning the mist lapped high enough up the hill to enter the forest, so I quickly headed over there. The conditions were perfect for less than five minutes, but long enough to get this stunning image (see also page 4).

SCALE

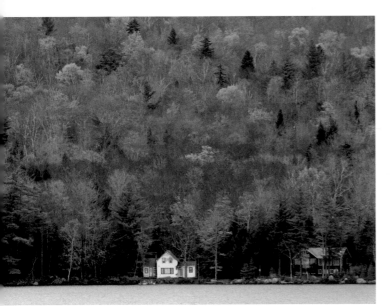

Fall foliage in New England, USA
Canon EOS 7D, 70–200 mm F2.8L, 1/125th sec, F5.6

Expert tip

Take a friend with you, if possible, to include as scale. Failing that, put the camera on a tripod and run in, or be inventive and look for something that you can get into the shot to show the scale.

Generally I like to photograph trees and forests in as timeless a way as possible. I try to avoid anything that might date the image too much and perhaps give it a limited life for sales and publication. However, there are times when it is useful to give the scale of a scene, a tree and even fruits and seeds. It is also sometimes beneficial to include something that locates the photograph too.

Left is a scene from New England, towards the end of the autumn. I like the feathery trees that have already lost their leaves in among the colourful reds and yellows. I used the lake edge and a couple of timber houses typical of the area to provide the scale, which emphasises the vast wall of trees rising up the mountain behind. I accentuated the effect by using a tele-photo lens to compress the perspective and give the impression that the trees rise almost vertically from the lake edge. The overcast light allows all the subtle shades and colours to be clearly registered. I used a tripod to eliminate any problems with camera shake.

Overleaf is a particularly well-known image of mine. The tree is one of the largest oaks in Europe and is likely to be more than 1,000 years old. It is referred to as a boundary marker in the Domesday Book. The photograph is fairly straight forward, but is greatly enhanced by the inclusion of the chicken. I waited for it to walk in front of the blackness of the hollow, which really makes it stand out. Without the chicken, the tree could look quite ordinary, rather than the 13 m girth monster that it is.

While photographing the most ancient trees, I regularly arrived at a situation where I decided that the inclusion of some scale would be useful. Generally, I was the only person around, so I would set the timer for a ten-second delay, run into the image and take up what I hoped were manly poses in front of many of the world's largest and most ancient trees. Overleaf I am standing at the foot of the sixth-largest surviving redwood in Sequoia National

The Bowthorpe oak, with a chicken included to emphasise the size of this thousand year old oak, Lincolnshire, England *Canon EOS 1n, 28–70 mm F2.8, 1/125th sec, F4*

Park, California. Without me standing next to it I don't think it would be possible to get an idea of just how big this tree is.

This classic-style bicycle was the ideal way to both demonstrate the sheer size of the trunk of one of the largest London plane trees in existence, (opposite) and highlight that it is now on an ancient tree trail in London linked by cycle routes. I placed tree seedlings in the bike basket to suggest the replanting of street trees in London that was being undertaken in the city. The image was taken around the end of the day, close to sunset, but the soft evening light filtering through the woods I think works perfectly for this scene. I used a tripod to allow me to use slower shutter speeds. The biggest difficulty was driving into London, hiring the bicycle on a day when the conditions were near perfect.

The photograph opposite, far right shows the seeds of the teak tree and I included the hand to provide scale. Seeds come in all shapes and sizes. Oddly, the world's largest tree (a *Sequoia giganteum*) has seeds that are like dust. Others, like Brazil nut pods and coconuts, could kill you if they dropped on your head. Scale can be very informative.

Me, standing by the sixth largest giant redwood tree, Sequoia National Park, USA *Canon EOS 1n, 28–70 mm F2.8, 1/30th sec, F5.6 (10 sec time delay)*

A bicycle resting against 'Barney' the largest London plane tree, London, England
Canon EOS 7D, 16–35 mm F2.8L, 1/15th sec, F5.6

Teak seeds in Java, Indonesia
Canon EOS 1v, 100mm f2.8, 1/125th sec, F5.6

CONCLUSION

I have had great fun photographing trees around the world over the last couple of decades and hope that you have enjoyed seeing a tiny sample of the images I have produced, as well as reading about some of the techniques that I employed to get them.

When I first started photographing it was very much as part of my work with organisations such as WWF, Royal Botanic Gardens, Kew, The Forest Trust and the The Forest Stewardship Council (FSC), to help campaign for the protection and sustainable management of the world's precious forest resources. It was interesting to discover the effect a good image could have and the sort of emotional response it could elicit .It delights me to think that I have taken images that have not only been instrumental in helping protect ancient trees and forests around the world, but which to many people, are considered beautiful to look at in their own right.

My hope is that this book will inspire you to go out and take fabulous photographs of the individual trees and great forests that grace our green planet, and also to appreciate and to help protect our natural heritage.

Canon EOS 40D, 135mm F2L, 1/30th sec, F16